BIDEFORD REFLECTIONS

Peter Christie and Graham Hobbs

AMBERLEY

First published 2021

Amberley Publishing
The Hill, Stroud, Gloucestershire, GL5 4EP
www.amberley-books.com

Copyright © Peter Christie and Graham Hobbs, 2021

The right of Peter Christie and Graham Hobbs to be
identified as the Authors of this work has been asserted
in accordance with the Copyrights, Designs and Patents
Act 1988.

ISBN 978 1 3981 0422 8 (print)
ISBN 978 1 3981 0423 5 (ebook)

British Library Cataloguing in Publication Data.
A catalogue record for this book is available from the
British Library.

Typesetting by Aura Technology and Software
Services, India. Printed in Great Britain.

Introduction

Everyone at some time or other must have wished for a *Doctor Who*-style time machine to revisit places in the past and see what they looked like. Old photographs are one way of doing this but trying to match them up with what is present today can be difficult – hence this book. In it we display a selection of 'old' photographs originally taken between 50 and 150 years ago and matched them up with a contemporary shot taken in as near the original photographer's position as possible. These have then been melded together to produce a simple 'then and now' view. The whole exercise was fascinating for us and we hope you will enjoy the result – Bideford's very own 'time machine'.

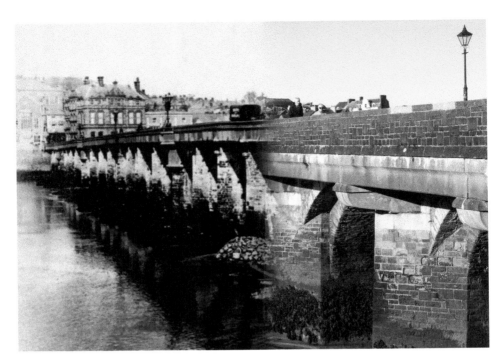

The Long Bridge of Bideford is the oldest structure in the town, originally dating, it is thought, from the late thirteenth century. Over the years it has been widened and in these two shots we see the iron parapets of the 1865 widening, with men working on strengthening the stirlings against the scouring action of the River Torridge. The second photograph shows the stone walling put in place in 1925 along with the reproduction 'vintage' lamps.

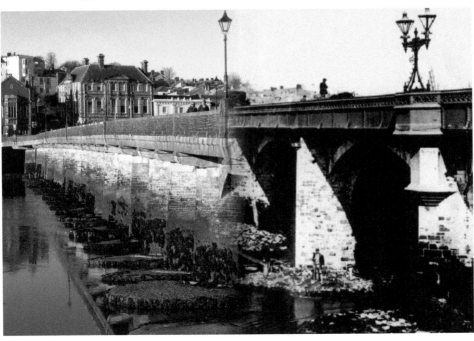

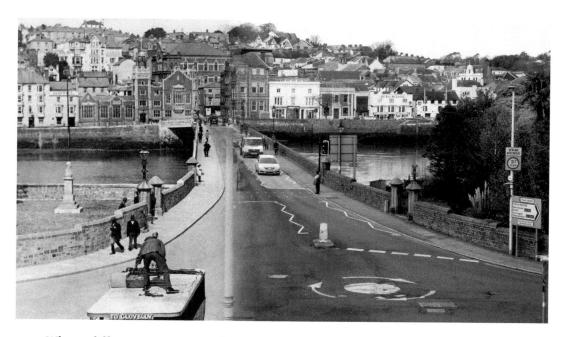

What a difference a century makes. In the 'before' photograph the bridge is virtually empty and even boasts a horse and trap crossing it. The tiny charabanc in the foreground bears the words 'To Clovelly', while the grassed areas either side of the bridge end are clear apart from the Pine-Coffin bust.

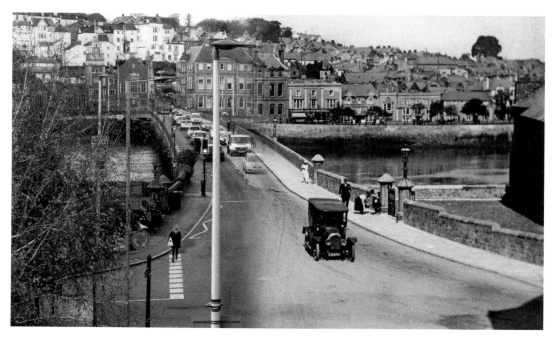

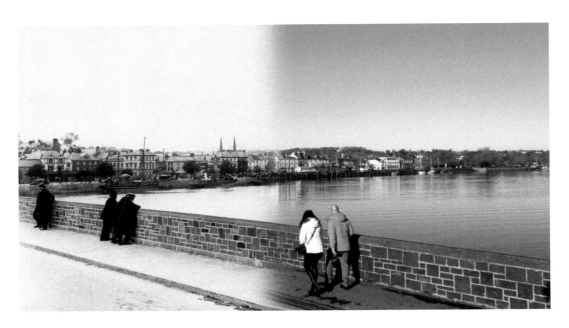

The Long Bridge still links East and West Bideford and is always busy with pedestrians enjoying an ever-changing view as the large tides come and go. Our two shots here are roughly a century apart but many of the buildings on the western side are still recognisable today, although the handsome sailing vessels have long gone.

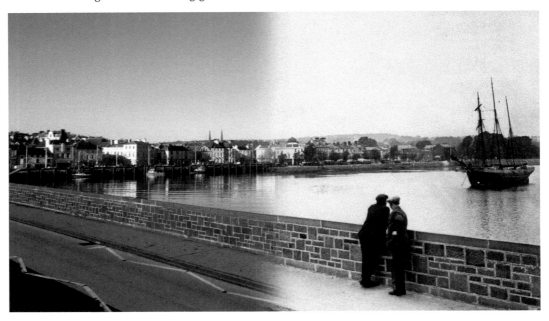

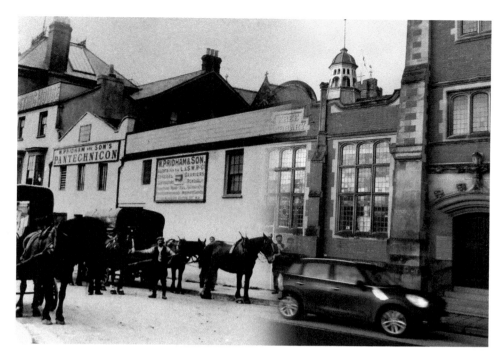

The firm of Pridham ran stagecoaches and freight wagons from their building at the western end of the Long Bridge. The offices are shown here with staff and wagons on show. To the left is the roof of Tanton's Hotel, and behind is St Mary's Church. In 1906 the new 'Free Library' was opened on the site and is still there today, while the hotel was recently converted into flats.

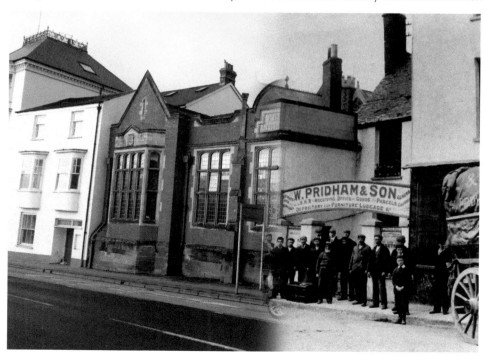

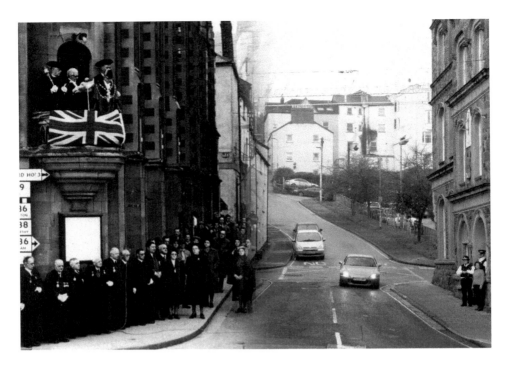

The Town Hall with the mayor of the day, Councillor W. H. Copp, and the town clerk proclaiming the death of George VI and the accession of Elizabeth II in 1952. The modern photograph shows the current town council marshalled outside the same building prior to marching up to the Pannier Market for the annual 'Signing the Lease' ceremony – with one of the authors (Peter) wearing the mayoral robes and gold chain.

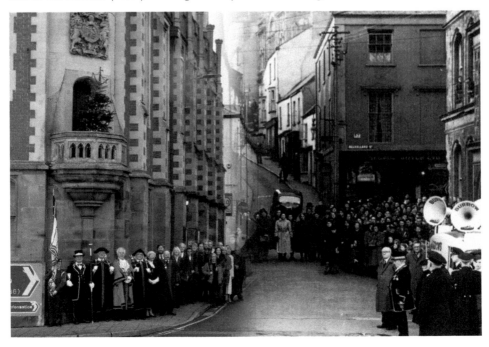

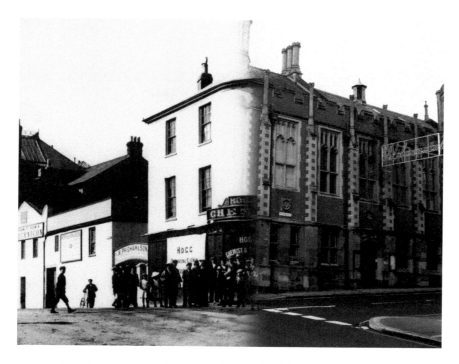

Hogg's chemist's shop occupied this corner for much of the nineteenth century. Eventually purchased by the town council, that body demolished it and added a new council chamber to the existing town hall in 1906. The Edwardian drainpipes bear the date 1905, the builder having been somewhat optimistic when he ordered them. Traditionally the proclamation of a new monarch and election results were announced from the small corner balcony but this has stopped now.

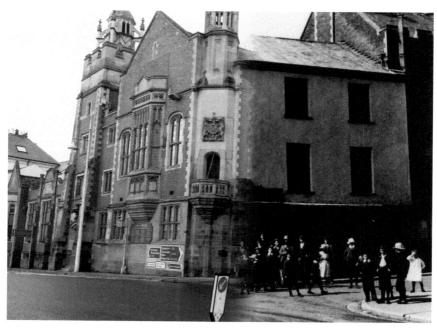

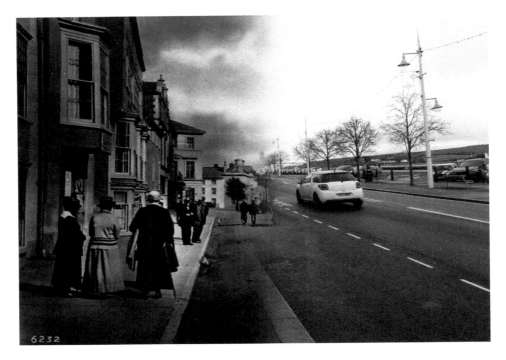

The bay windows of the 'Rose of Torridge'/'Mr Chips' on the left help place these shots. In the earlier pre-First World War picture the road has two carts and one car present while the present-day shot has rather more cars evident. The new trees lining the Quay are set back further from the roadway than their Edwardian counterparts – and the streetlights are rather taller, and more efficient, in the contemporary scene.

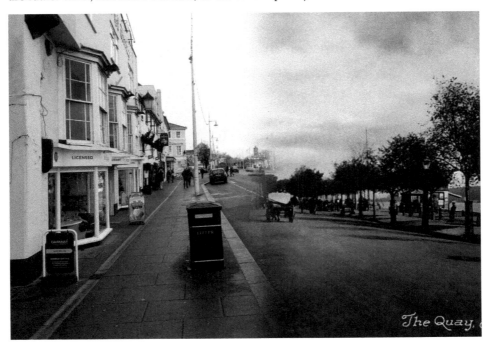

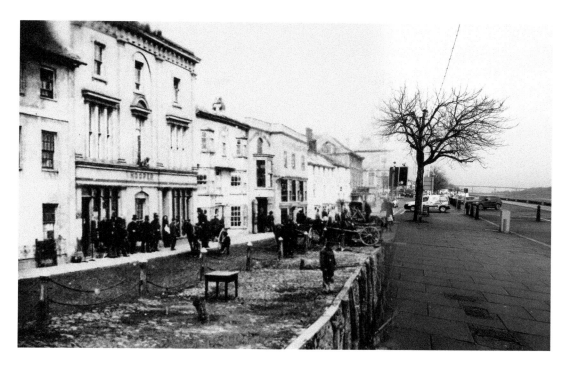

Bideford Quay originally began in front of today's Conduit Lane – with private gardens lining the riverside from there to the bridge. Over the years the Quay has grown, both in length and breadth, as is clear from the contemporary shot. The earlier photograph is possibly the earliest in this book, dating as it may from before 1857.

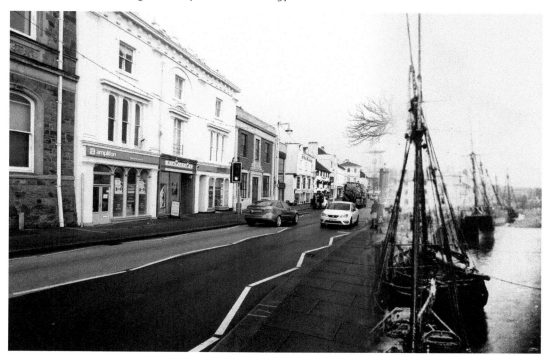

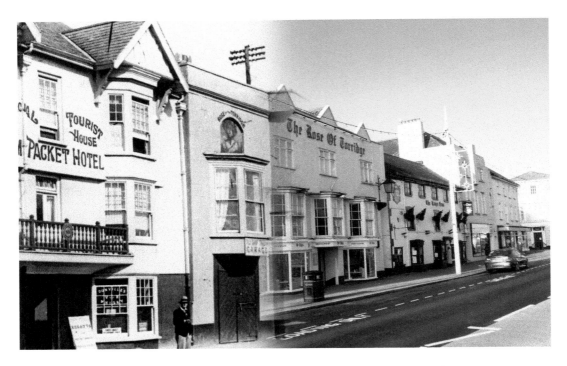

People say 'Bideford never changes' but these pictures should convince them they are wrong. Compare the 1920s photograph with today and you will see that three buildings have gone completely, with the last, next to 'Mr Chips' only having been replaced within the last few years. At one time there were four public houses along this stretch of Quay, with only the King's Arms now remaining.

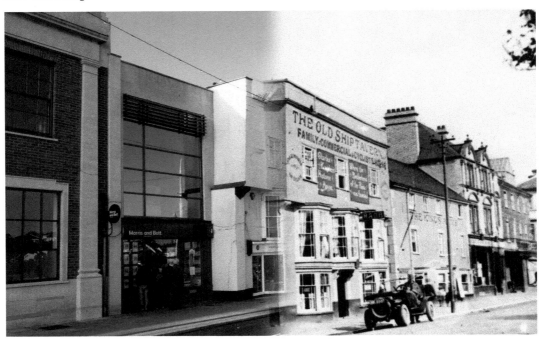

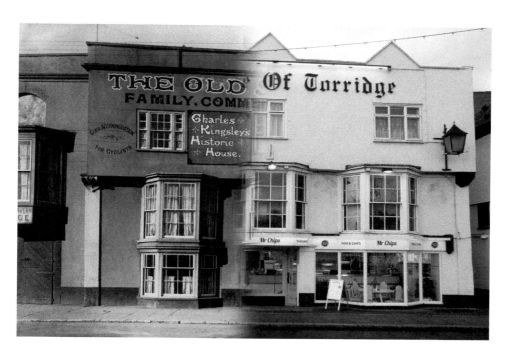

This building can trace its history back to 1626 when it stood on the edge of the Quay. The reference to Charles Kingsley links the building with the author's Victorian bestseller *Westward Ho!* – nothing like cashing in on a bit of free publicity. Today the building houses a fish and chip shop while the garage next door, later a hairdressers, was recently demolished and replaced with a twenty-first-century building. The Quay edge is now some distance away but note the step down into the building – the Quay has also been raised over the years.

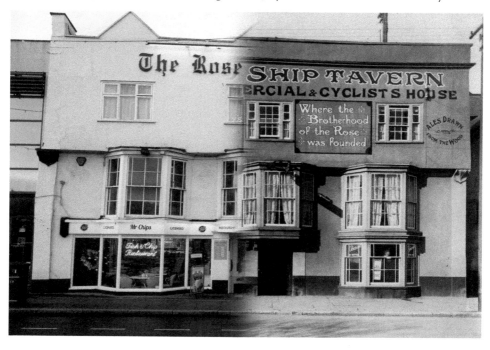

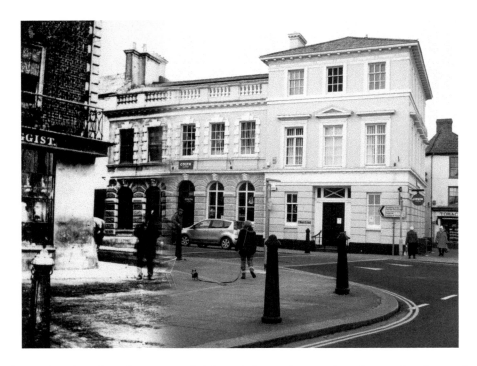

This grainy shot dates from around 1869 and shows the premises that used to house the NatWest bank. The railings in the shot were erected after a stagecoach plunged over the Quay in 1847 when seven passengers were drowned. Today, as with so many branches, the bank has left and the building has been refurbished, in this instance as a Costa coffee shop. The present-day bollards are there to stop lorries mounting the pavement – not a problem the Victorians experienced.

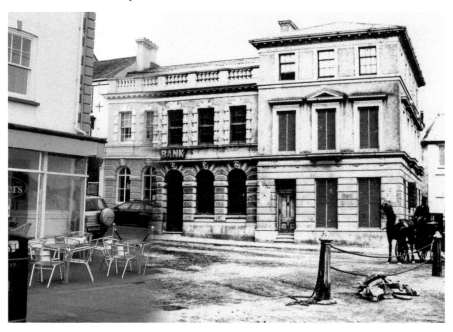

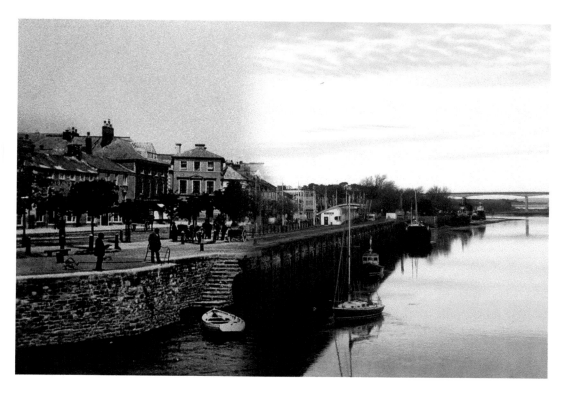

Bideford harbour still receives ocean-going ships collecting china clay from local quarries for export around Europe, but they are far larger than the small coasting vessels seen in the Edwardian photograph here. Just over a decade ago the riverside wall was completely refaced and the Quay extended out into the river another 6 metres. Note the difference in levels of the water, indicative of the large tidal range of the River Torridge.

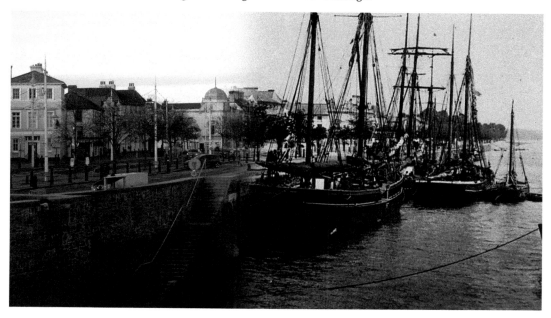

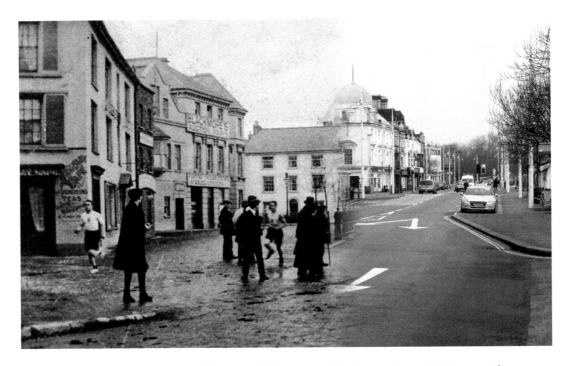

The 'early' shot dates from around 1910 and shows an athletic race along the Quay, with an engine of the Bideford, Westward Ho! & Appledore Railway on the right. Today most of the buildings are still recognisable other than the cupola-topped garage, which appeared in the 1930s. Needless to say races are no longer staged along today's very busy road.

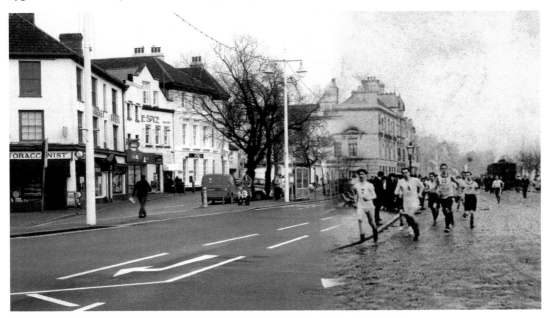

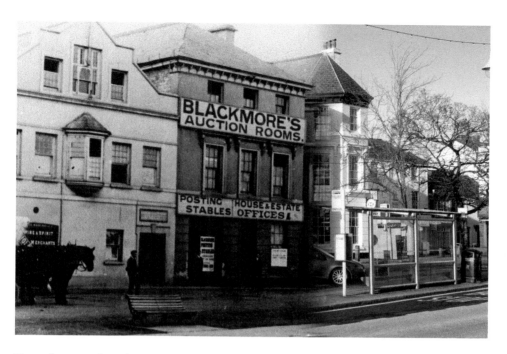

Two photographs of a section of the Quay 120 years apart. The buildings are still recognisable, though their occupants have changed from an auctioneer and wine merchant to an Indian restaurant and a bank. What is noticeable is the profusion of modern street furniture – bus shelters, telephone boxes and litter bins fill the scene.

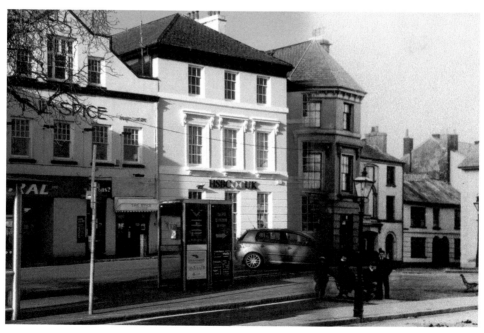

Another pair of shots of Jubilee Square, the first from around 1912 with a fascinating display of early motorcycles including one with a very comfortable-looking sidecar – and no copper cupola present. The modern shot shows how Blackmore's auction rooms on the left have become the HSBC bank while a large tree has grown in the square.

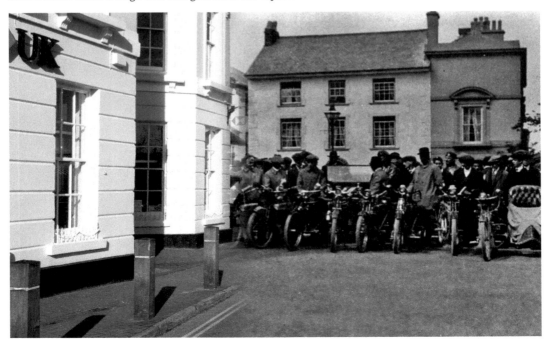

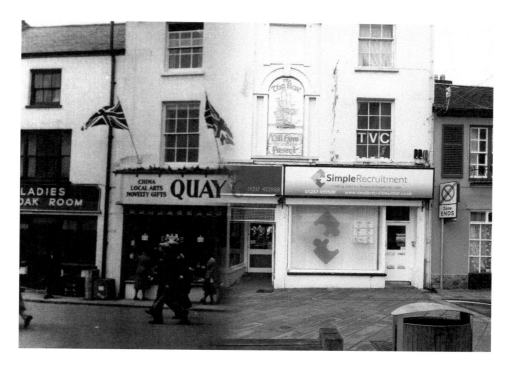

Jubilee Square is named after Queen Victoria's Diamond Jubilee in 1897, though the 'early' photograph in this shot shows the main shop decorated for Queen Elizabeth's coronation in 1953. Notice the two-digit telephone number for the Quay Gift Centre and the 'Ladies Cloak Room' for bus passengers. Today the shop is split into two units and the 'Cloak Room' hosts a local taxi firm.

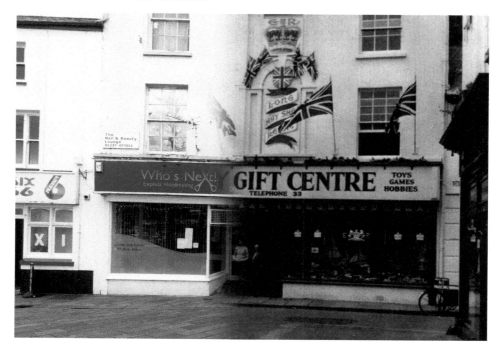

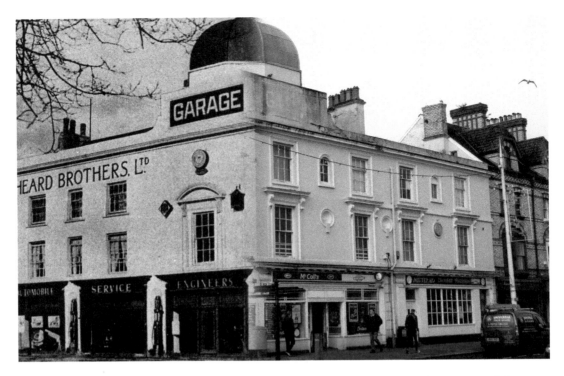

One of the notable features of the Quay is the copper dome on the top of this old garage in Jubilee Square. Erected in the 1930s, Heard Brothers sold petrol (note the pumps in the niches) and were agents for Chevrolet, Ford and Buick. Today the building houses a convenience store with flats above.

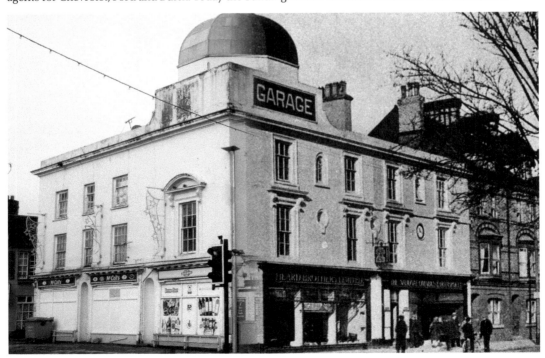

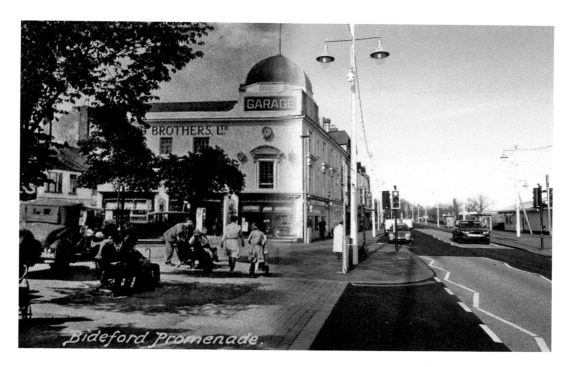

Bideford Promenade.

The 1930s postcard reproduced here shows a fine array of buses passing Heard Brothers garage in Jubilee Square, while the contemporary shot sees the garage converted into a convenience store, though the copper cupola is prominent in both.

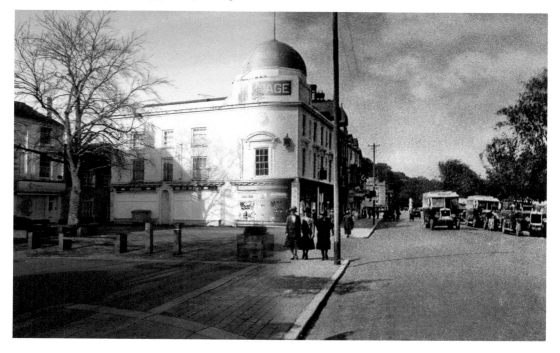

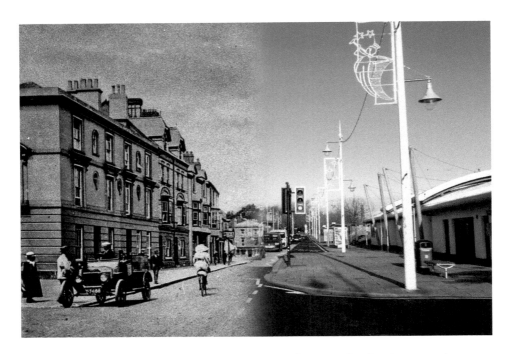

The first car seen in Bideford arrived here, it is said, in 1896 but by the 1920s they were becoming relatively common, as shown on a postcard from that decade. Today the road has far more vehicles along with the new Lundy and Harbour Master's offices on the right. Some young trees have replaced the earlier ones, which had either died or been seriously damaged by passing buses and lorries.

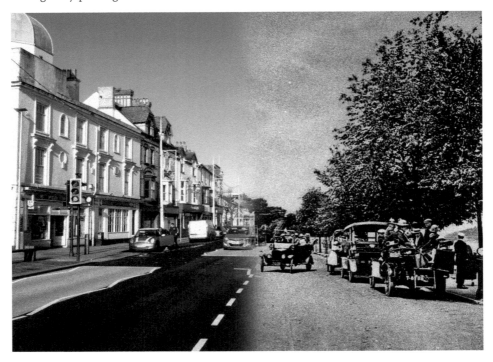

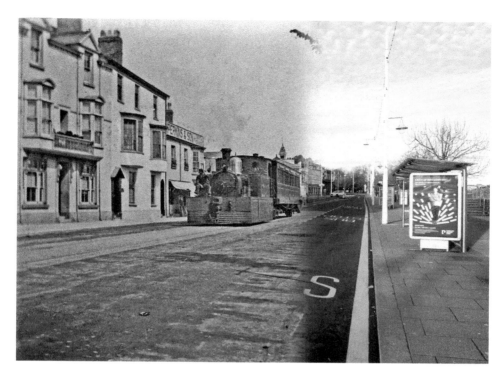

Another shot of the Bideford, Westward Ho! & Appledore Railway trundling down the centre of the Quay around 1910, complete with US-style 'cowcatcher' on the front to tackle any stray animals encountered on the more rural sections of the line. The modern photograph has most of the same buildings, though the trees, planted just over a decade ago, have been moved back from the roadway and the balcony on the building on the left has gone.

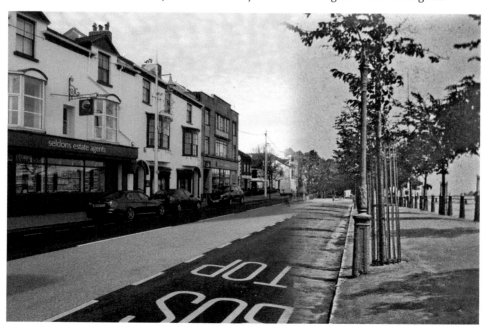

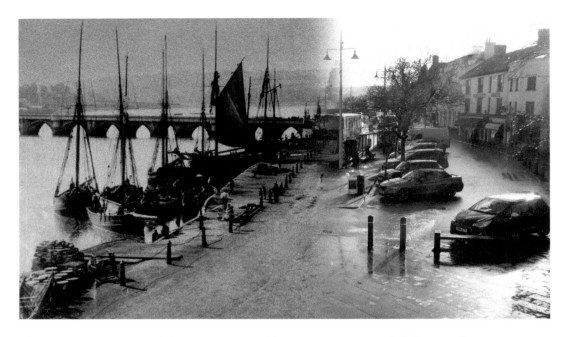

These panoramic views of the Quay are roughly 120 years apart and differences leap out at the viewer. Firstly the Quay now has no vessels tied up alongside, and the roadway has been widened. New street furniture in the shape of lamp posts, benches and bollards is present, and the view is full of vehicles demonstrating the triumph of road transport over shipping.

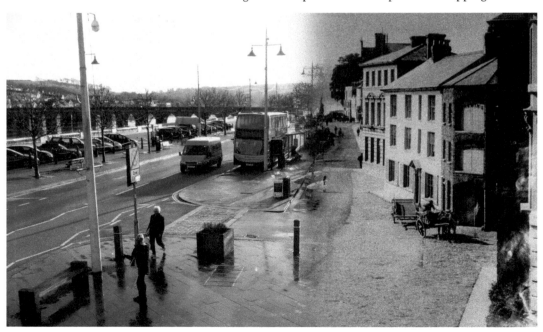

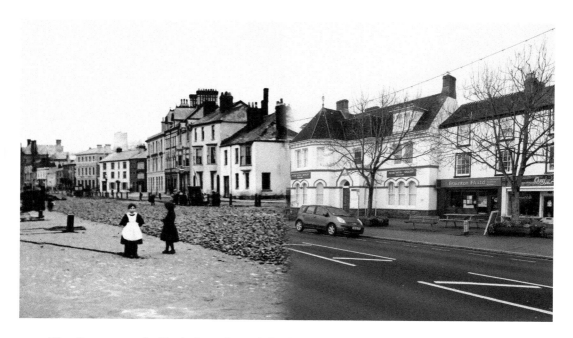

The Quay around 1880 before the Bideford, Westward Ho! & Appledore Railway was laid down or trees were planted. Apart from the disappearance of the white building in the centre and its replacement with some building society premises (built in 1962–63) the view is much the same for the buildings, though shop fronts have been altered and modernised over the years.

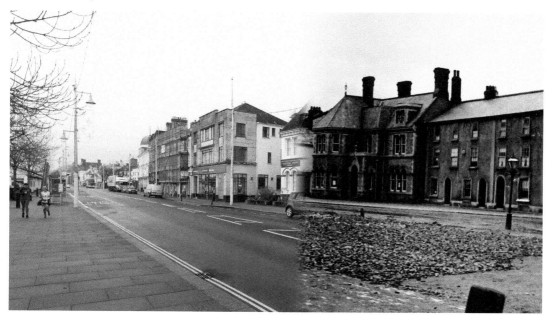

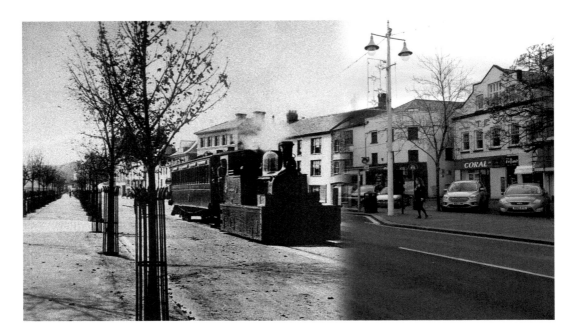

The Bideford, Westward Ho! & Appledore Railway has to be one of the shortest-lived railways in Britain. Opened in 1901, its three engines were commandeered in 1917 to help the war effort, with its rails and carriages being auctioned off in 1920. It is hard to believe today that it once ran down the centre of the Quay, but here is the evidence. If it was still here one wonders how car drivers would fare?

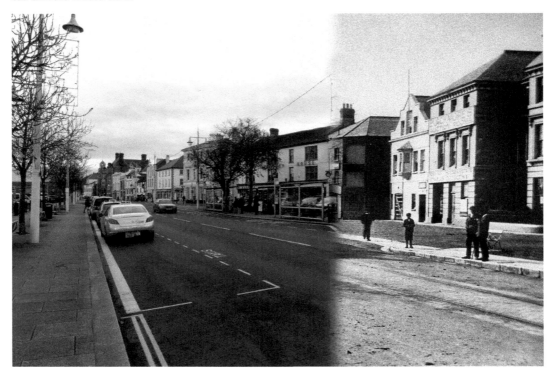

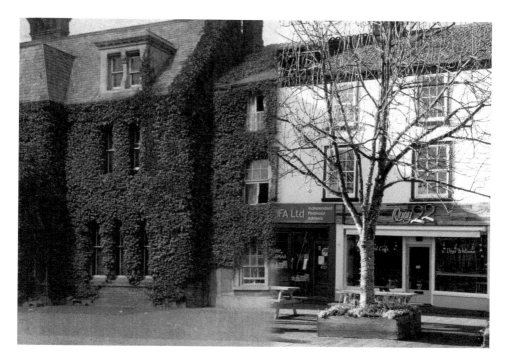

The foliage covering these buildings would make it difficult to identify them without the modern shot to compare. Grenville House on the left occupies the site that once housed the Mayor's 'Mansion House', which also doubled up as a theatre. Now housing a firm of solicitors, the two shops next door had their small sash windows replaced by large plate glass ones, but as is usual the upper storeys remain unchanged.

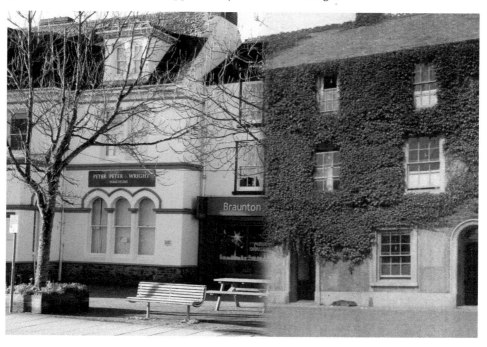

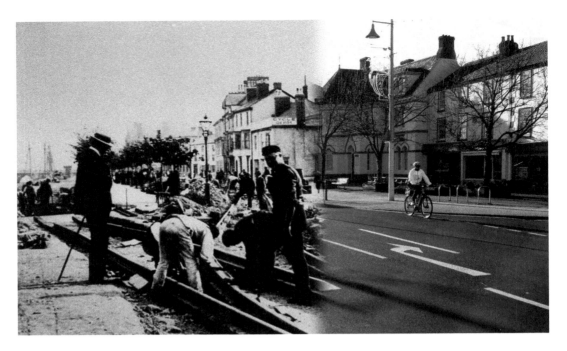

In 1898 work began on constructing the Bideford, Westward Ho! & Appledore Railway, it being extended to Appledore in 1908. The town council opposed its planned extension along the Quay but the company behind the scheme cited a technicality in the Parliamentary Act setting them up and construction began. The line is shown being laid down, with the modern shot showing how cars have replaced the railway.

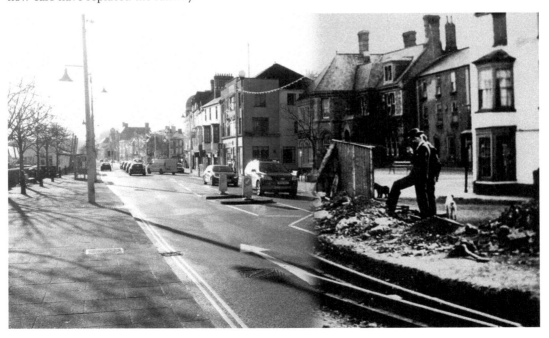

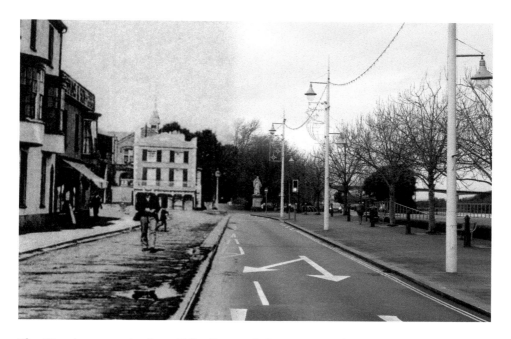

The Kingsley statue in the middle distance helps orientate this picture. The rails of the Bideford, Westward Ho! & Appledore Railway are still in place and the trees along the Quay are still fairly small while the Manor House to the left of the statue is still standing in front of the Art School. In the modern photograph the latter is now partly hidden by the bland architecture of the post office, with a second lot of newly planted trees along the river side of the road and some modern lamp posts harking back to the masts of sailing ships.

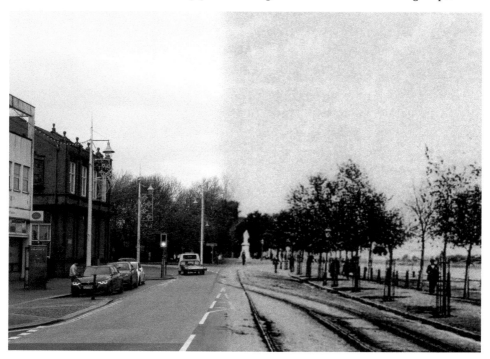

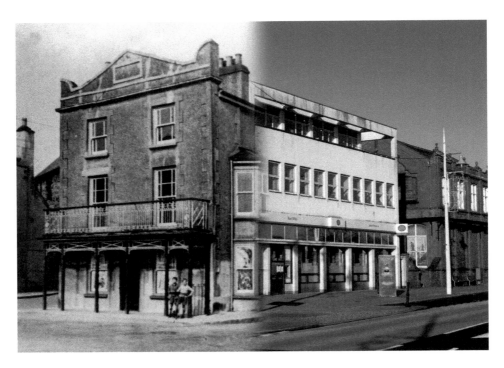

Most readers will not recognise this building. It was known as the Manor House and was erected around 1832 by the then lord of the manor. It was removed just before the Second World War, with today's post office being built on the site between the Art School and the Customs House (today's Pannier Pantry), the former of which appears in both shots.

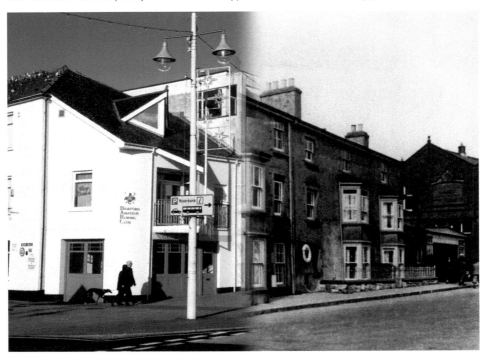

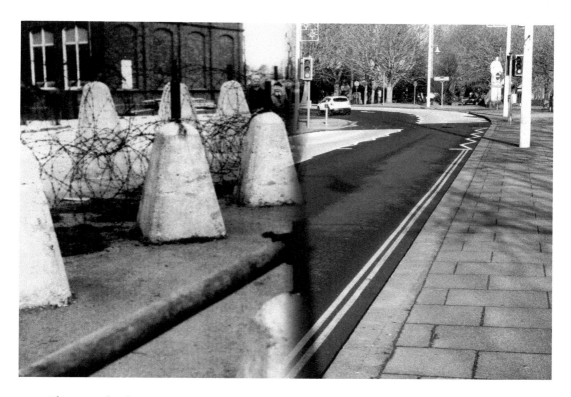

The Art School corner on the Quay is shown here in 1940 and 2020. The 'dragon's teeth' and barbed wire were hurriedly put in place when there was a real fear of an imminent Nazi invasion, although their positioning seems very odd in hindsight. The modern photograph shows a far more peaceful scene with more trees in Victoria Park.

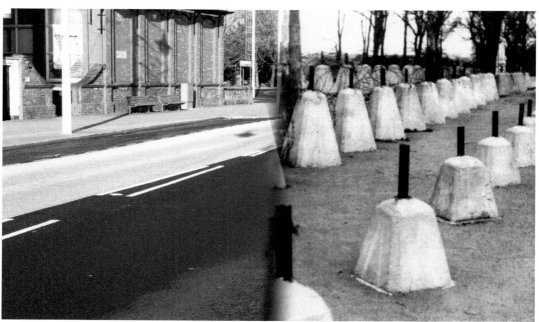

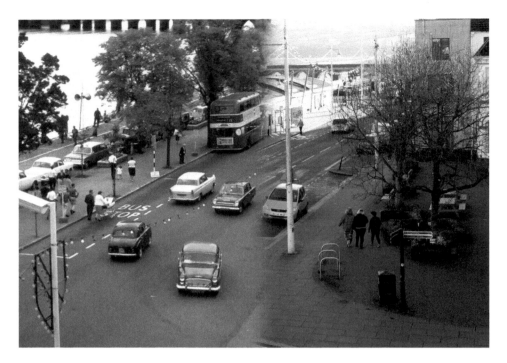

The Quay is the main vehicular artery of Bideford as seen in these two shots that are getting on for fifty years apart. What does stand out are the changes both large and small, from the Harbour offices and new lamp standards to the flood prevention wall and bike racks. The rather disparate collection of old and damaged trees have been replaced with new healthy ones, though their winter absence of leaves makes comparisons difficult. In both, however, the bridge still remains serenely present.

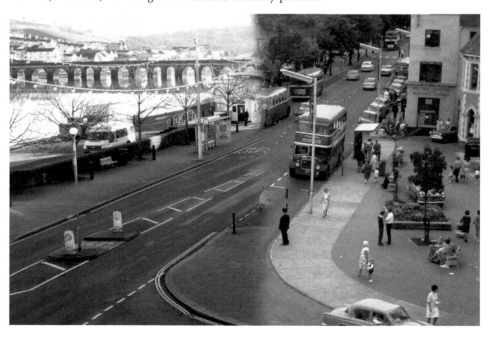

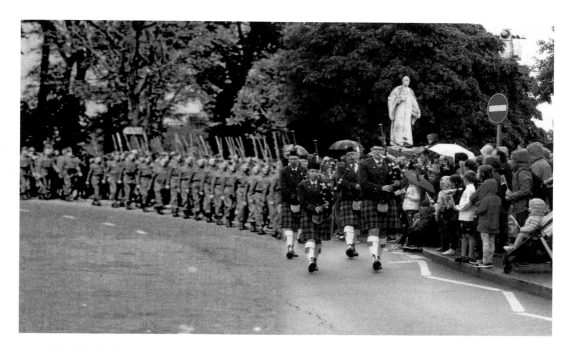

The Bideford Home Guard are seen marching along the Quay in front of the Kingsley Statue during the Second World War. Such parades boosted morale when it was needed and were an important part of the war effort. The modern picture shows another, less martial parade: the Bideford Youth Pipe Band.

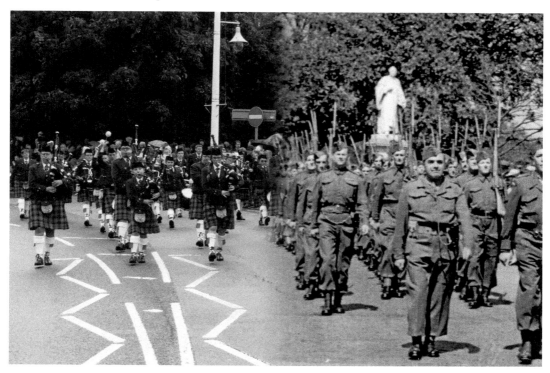

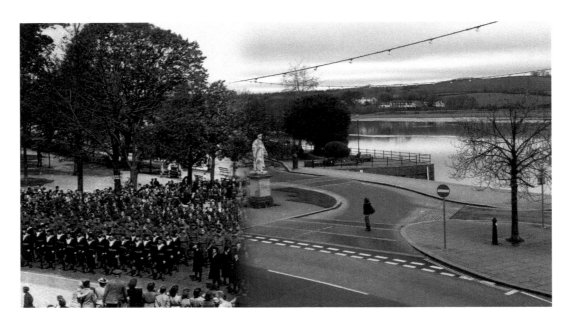

The Kingsley statue anchors both these shots. One dates from the Second World War when a huge parade of service personnel, both Regulars and Home Guard, was staged to boost morale. The second shows a rather less crowded scene with Kingsley now isolated on a traffic island, and a new car park and an extended riverside walk behind him.

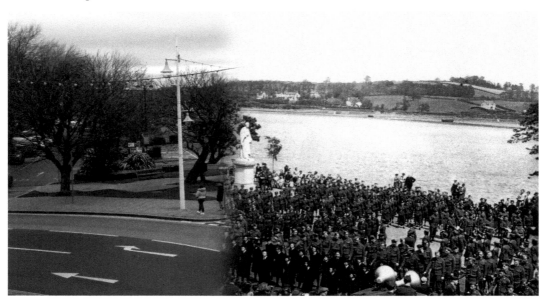

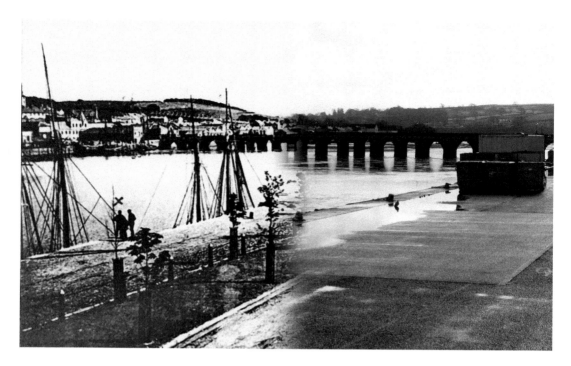

The Victorian view dates from around 1895 with the newly planted trees present but, as yet, no railway tracks of the Bideford & Westward Ho! line. What doesn't appear on the modern picture is the flood defence wall set back some way from the river's edge, which was erected just over a decade ago to cope with the inevitable rise in sea level associated with the global warming crisis.

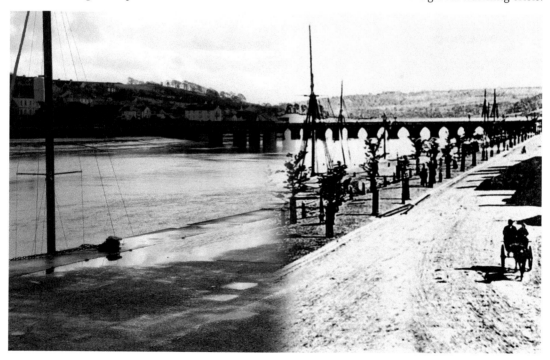

These two shots could hardly be more different. In the late Victorian one the Kenwith stream is seen running parallel to the Quay before entering the River Torridge, roughly in front of where today's post office is sited, while a small footbridge linked the riverside walk to the Quay. In the modern shot the now culverted stream flows out into the river behind the Kingsley statue and its now filled-in stream bed forms part of the roadway, thus explaining why the tarmac sinks occasionally.

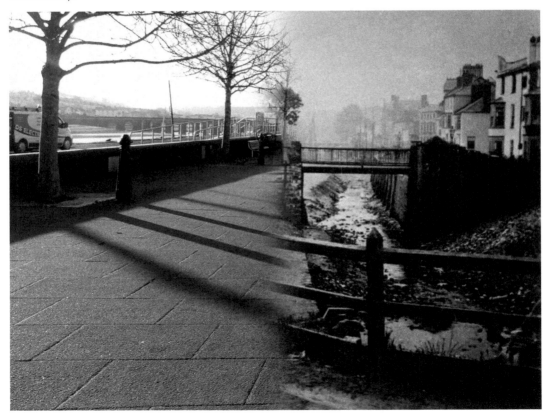

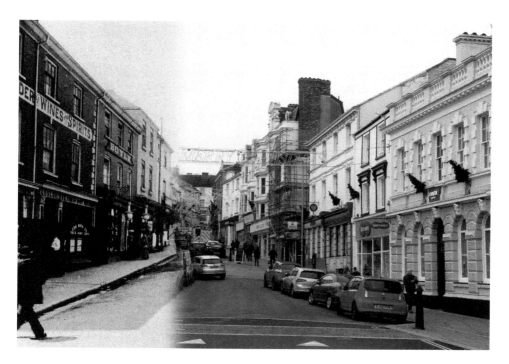

Bideford High Street in the late Victorian period where just horse traffic appears in the old photograph. This area of the road is wide as it once held the town market, which moved to its present site in 1675. In the second photograph most of the buildings are still instantly recognisable but the main difference is the large number of ever-present cars, a common feature in all our towns and cities today.

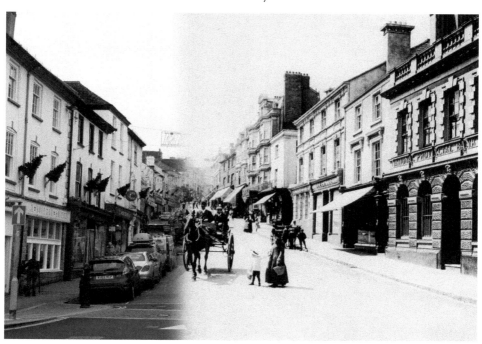

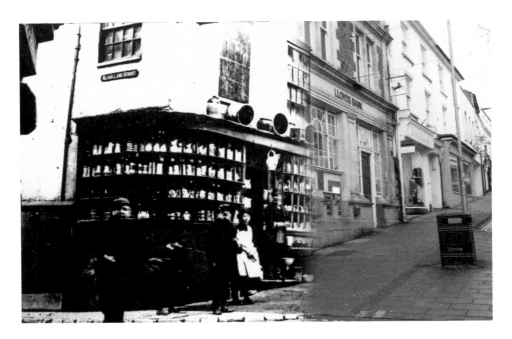

Without the nameplate of 'Allhalland Street' above this old crockery shop people might find it difficult to locate Mr Green's premises. They stood on this site for many years until replaced by the present-day Lloyds Bank. Notice how the Victorian pavement line has been extended out as part of a traffic calming exercise – though 'boy racers' still fly up High Street.

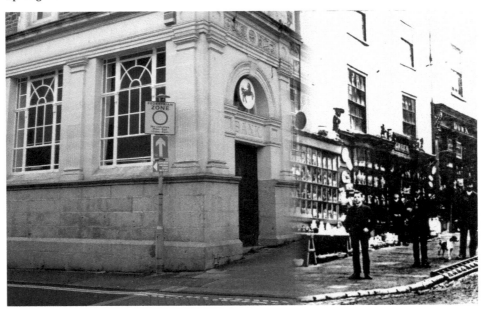

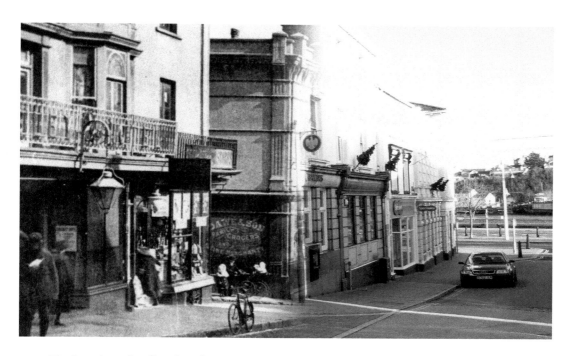

The junction of Mill and High Street has always been a prominent shopping site and in the late Victorian view we see Dawe's grocery shop and the Kingsley Hotel, now replaced respectively by Barclays Bank, a 'mobility' shop and the New Look store, though the old NatWest Bank, now a Costa, adjacent to the Quay is still recognisable.

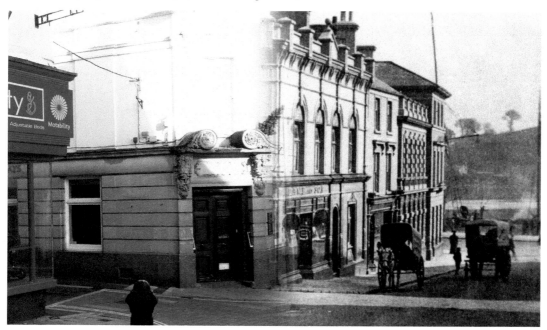

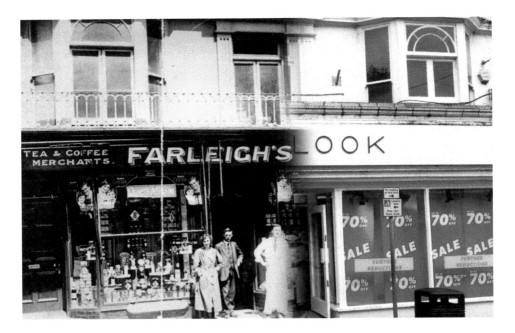

Farleigh's Stores were typical of the old-style grocers, which had beautiful window displays and owners living above the shop. The 'early' photograph dates from the 1920s while today's example shows a completely different business with a new series of large windows and doors. Note the period details in the windows on the first floor that are apparent in both pictures.

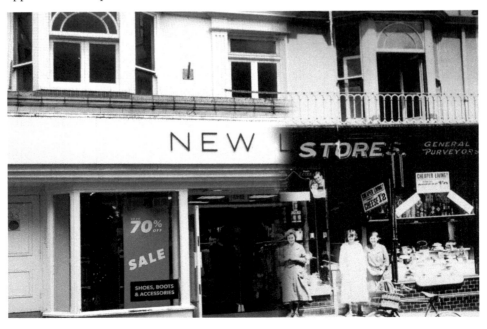

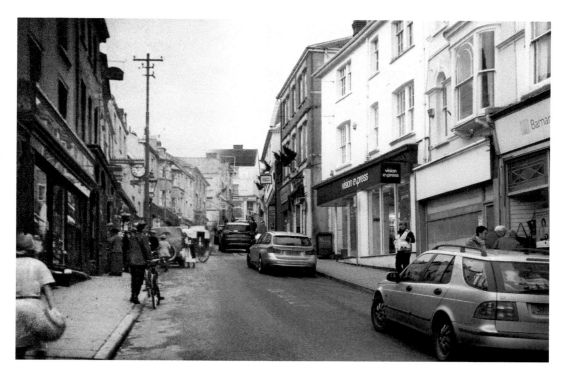

Looking up the mid part of the High Street roughly a century apart. Most of the buildings are still the same but all the shop names have changed – and where have all the sun blinds gone? One new presence is the traffic warden, though Bideford is still one of those rare towns where you can actually park for free, if only briefly, in the High Street.

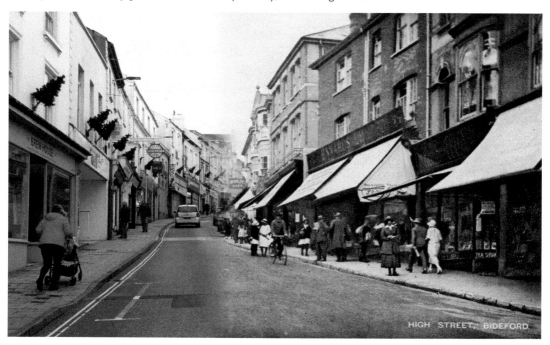

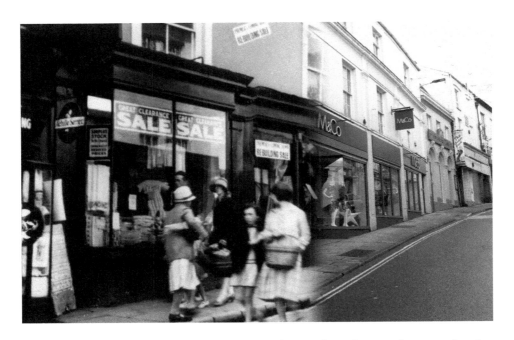

Chopes department store was the main shop in the town's High Street for many decades. Renowned for the quality of its products and its inventive advertising, it finally closed in 2011. The photographs here show it in the 1930s just prior to a major rebuilding, while the modern one shows a later remodelled front and its new tenant M&Co. Walter Henry's bookshop is still run by the Chope family in a shop boasting beautiful curved windows.

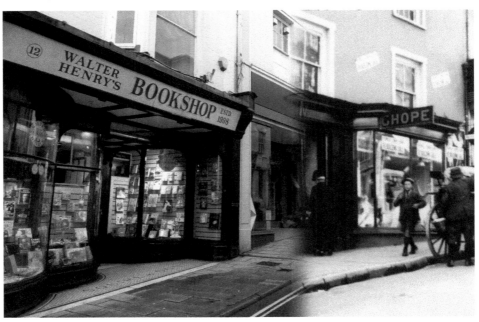

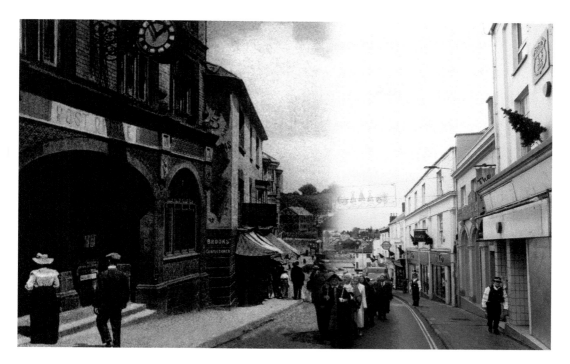

The Edwardian High Street has no cars, even outside the post office on the left. The shops have gas lamps outside of them and people are casually walking in the roadway. The modern photograph also has people in the road only this time they were the town council marching up to the Pannier Market. Note the bookmakers now occupying the post office, with all the lighting now inside the shops.

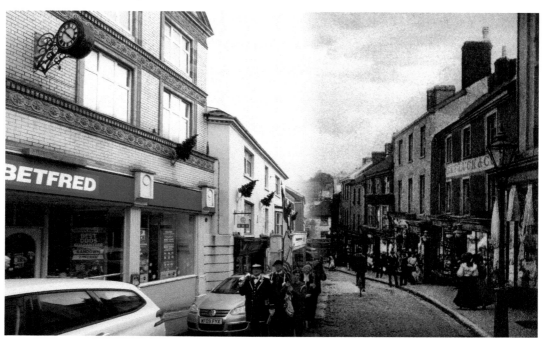

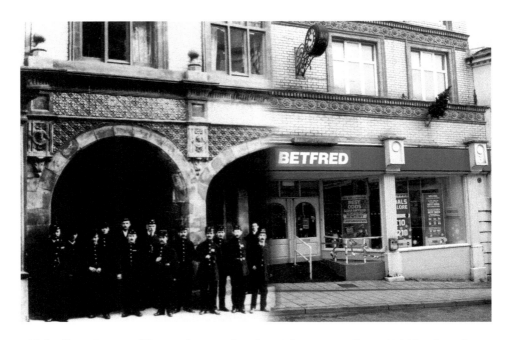

Bideford's main post office used to stand in the High Street. Built in 1886 (the date plaque is still visible on the front wall) on a site owned by the Bridge Trust, it was for many years the communication centre of the town but in 1959 it was moved to the Quay. Here we see the town's postmen around 1890, while in today's shot a national chain of bookmakers operates from the premises. The clock is present in both, though today's example is a replacement for the original.

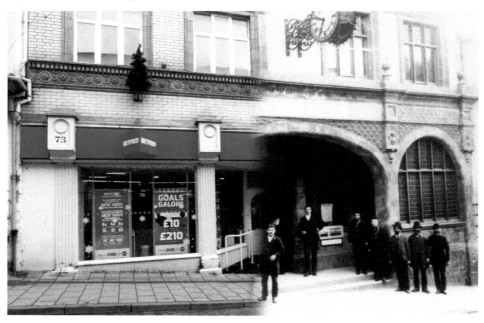

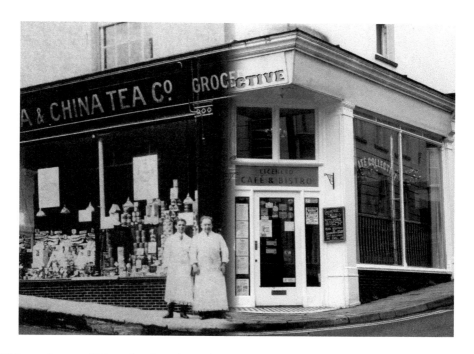

This modern café is to be found on the corner of Grenville and High Street. One of its earlier incarnations was as a branch of the India & China Tea Company. Note the all-male assistants in their traditional work 'aprons'. No self-service back then of course; you presented a list of goods you wanted and the assistants fetched them for you. The modern bollards were put in place a few years ago to stop large goods vehicles mounting the pavement as they turned the corner and threatened the plate glass windows.

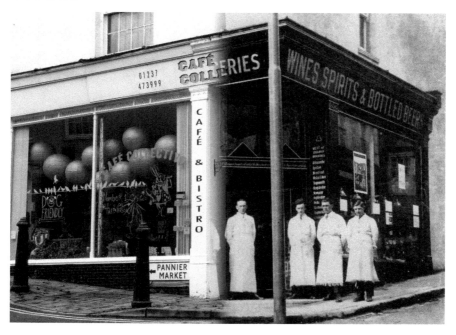

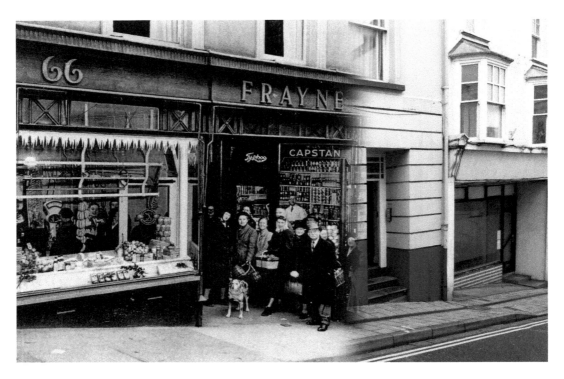

As with so many old shops shown in this book, competition from large supermarkets and internet shopping has led to their demise. Frayne's was a grocer-cum-butcher's and here from 1955 we see mainly female shoppers queuing to buy Christmas joints and fowls. Today the shops have gone and the building has been converted into flats.

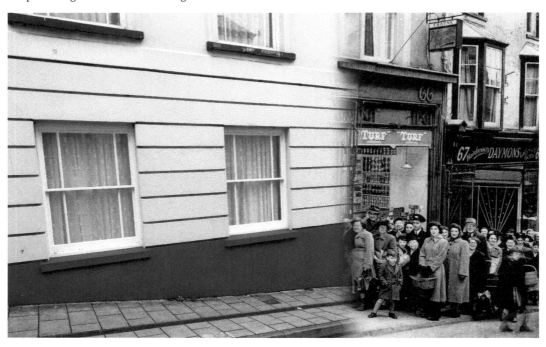

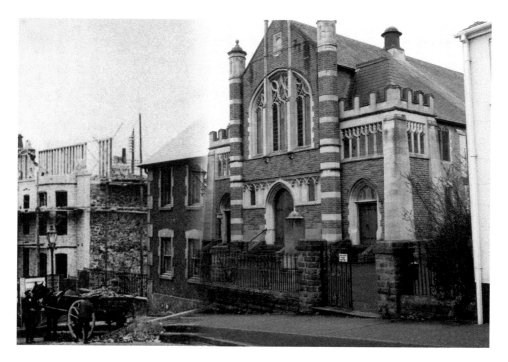

The almost fortress-like Methodist church in High Street was opened in 1913 and the earlier of these two photographs shows the area apparently before building began. The two white brick houses to the left are under construction and note how the double step pavement curb has been smoothed out with modern tarmac.

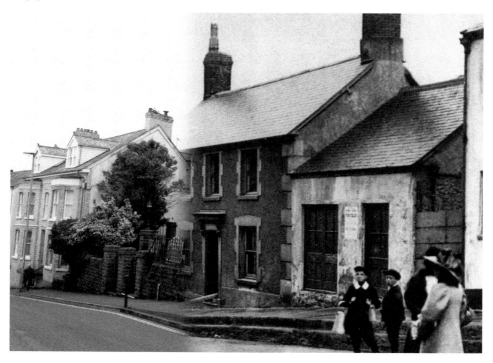

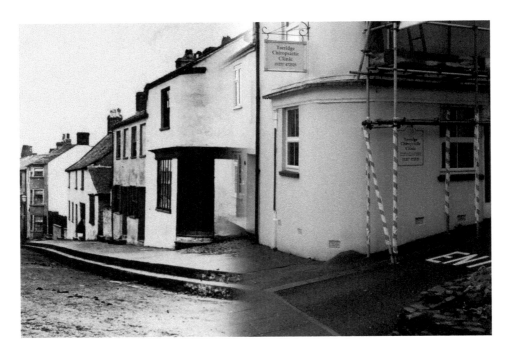

The top of the High Street around 1900 showing two diminutive shops with their small paned display windows with a horizontal sliding sash window above one of them. In the modern shot the lower shop is still recognisable but the stepped pavement has disappeared under a sloping layer of tarmac while the third house down has been demolished to make way for the High Street Methodist church.

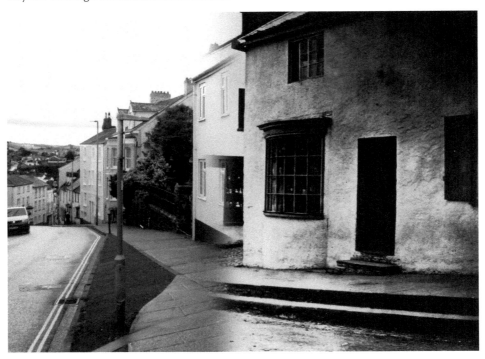

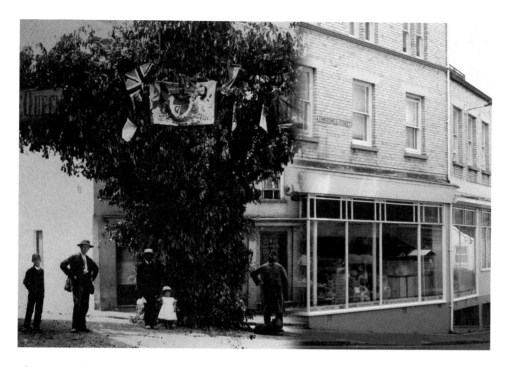

These two photographs possibly show the greatest change of any in this book. The earlier one dates from Queen Victoria's Diamond Jubilee in 1897 and shows the ceremonial arch of evergreens erected at the junction of North Road and Chingswell Street. The same view 125 years later shows the white brick 'Manchester House' – the old Yeo's drapery emporium now converted into a pet shop with flats above.

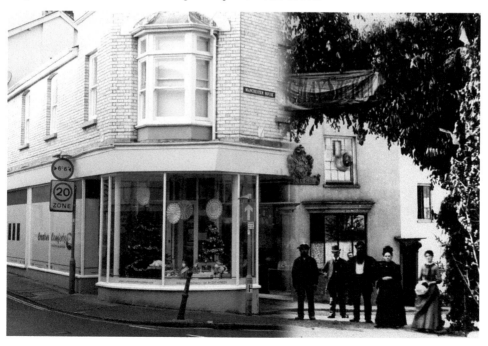

These buildings at the junction of Willet and Mill Street have undergone huge changes between the taking of these two pictures. In the first a very ancient-looking cottage sits in the centre, with the spires of Lavington behind it. In the second it and the adjoining building have both gone to be replaced by two white brick buildings ('Trawlers' to the right dates from 1933–34). Indeed only the bay window of today's 'Quencher's' and Lavington's spire appear in both.

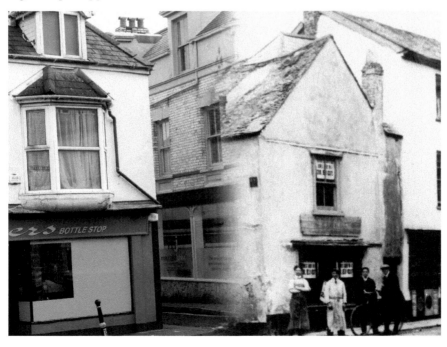

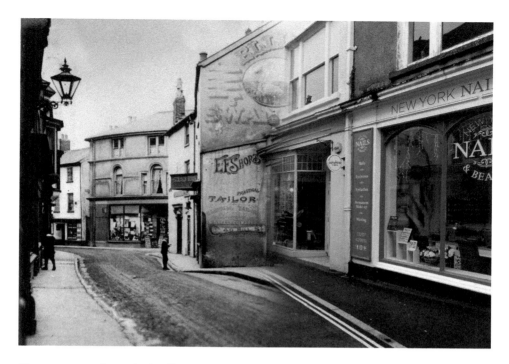

Here we are at the end of Mill Street facing the curving buildings at the top of Bridgeland Street. The Victorian photograph shows an attractive wall painting for the Swan Inn and E. F. Short's tailoring establishment while the contemporary shot sees a brightly painted shop and an example of the ever-spreading 'nail bar'. The shopfronts have been greatly altered, which has had knock-on effects on the road.

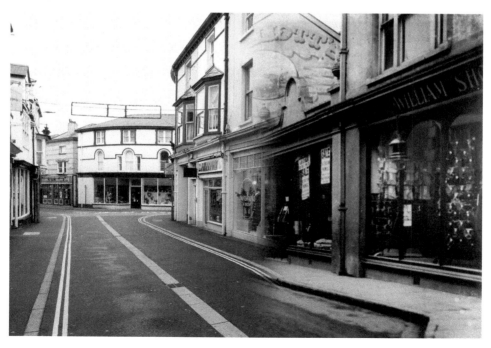

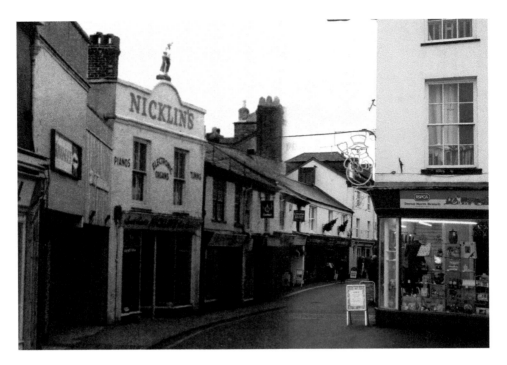

Mill Street is one of the town's main shopping streets, although, as with all places, the names of the shops constantly change. The Ragged Newsboy atop the central building is shown selling the *Western Express* newspaper, a publication produced in this building for many years by one Thomas Tedrake, an early Bideford photographer, journalist and town councillor.

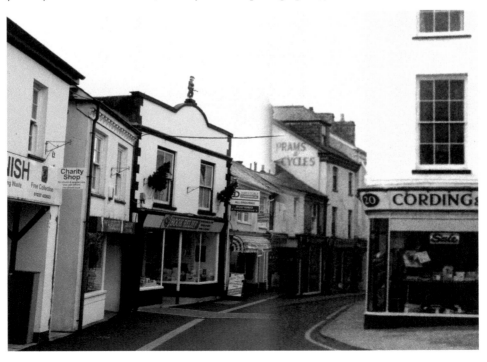

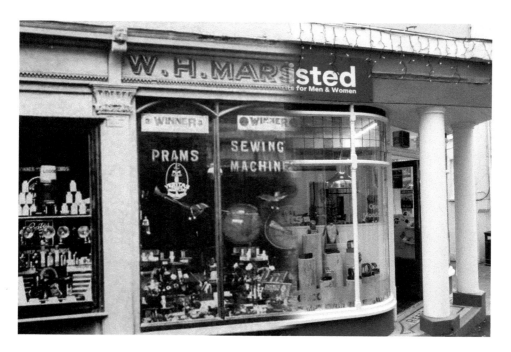

This small shop on the corner of Cooper and Mill Street has housed many different businesses over the years. Here in the 1920s Mr Marshall was running his cycle/sewing machine business, with a pair of nice-looking gramophone horns in the window display. Today the shop plays host to a belt shop while two columns now flank the doorway.

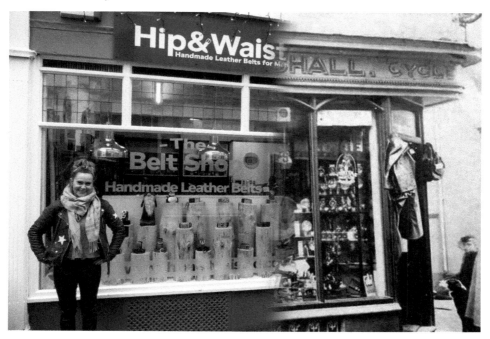

Bridgeland Street is seen here in two shots, one from the early 1970s and one from 2020. Most of the buildings, now safely listed, are still here with just a few small changes. The building on the left-hand corner was demolished to be replaced by a charmless example of twentieth-century brutalist architecture.

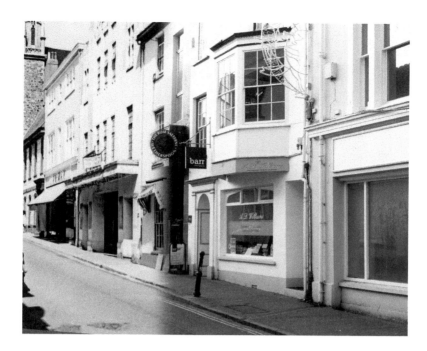

Bridgeland Street was laid out and first developed in the 1690s by the Bridge Trust. As time went on some of the original merchants' houses became retail outlets. Warmington's Garage as a motor garage dates from 1905 while the Palace Cinema (with the large overhanging canopy) was built in 1869 as a public/music hall, which became a cinema in November 1910. In 1969 the Palace was demolished and Ford & Lock's supermarket built in its place. This in turn later became a carpet shop, and today it is a Wetherspoon's public house.

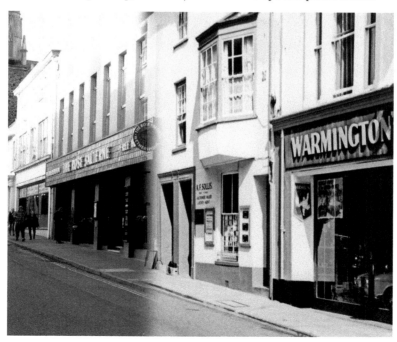

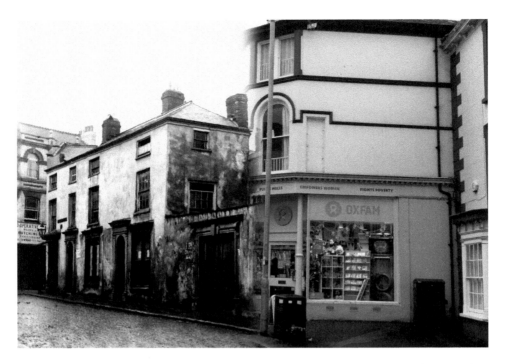

Bridgeland Street, as already noted, was created by the Bridge Trustees in the 1690s but over time some of the buildings deteriorated, as shown here. In the Edwardian period the Trust rebuilt this corner with large three-storey buildings, with the corner of the present-day Citizens Advice Bureau building just squeezing in on the right of each shot.

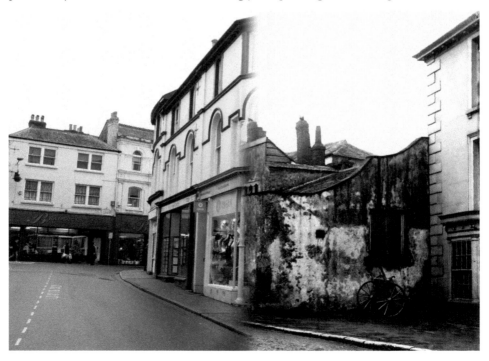

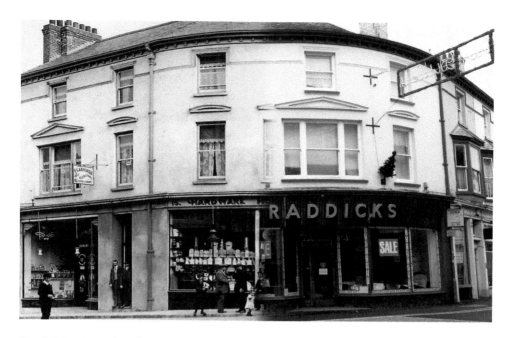

'Braddicks Corner', at the junction of Mill and Bridgeland Street, records the fact that this local firm have leased these premises for at least a century from the Bridge Trust. In the Edwardian shot Hobart Braddick has a wonderful display of crockery while in the modern one the family are selling furniture. The sweet shop to the left is now an optician's while the Swan Inn to the right was closed in 1972 by the owners Truman's Brewery.

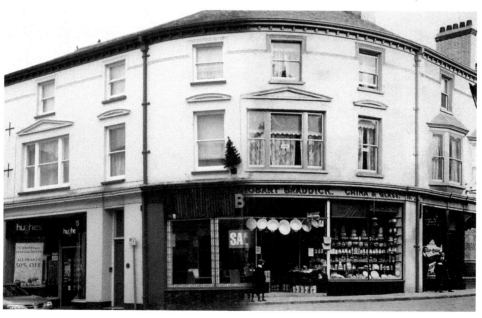

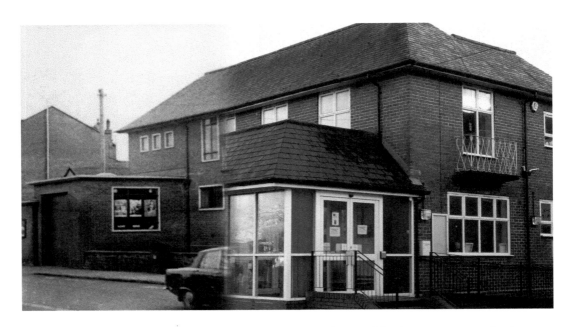

These two photographs show the same building on The Pill some fifty-three years apart. In the 1967 shot the building was being used by the local Territorial Army unit, among other groups, with the 'Blue's' rowing club to the right. Today the now slightly extended building houses the Bideford Youth Centre.

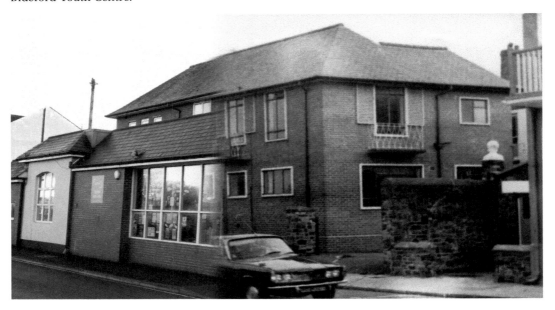

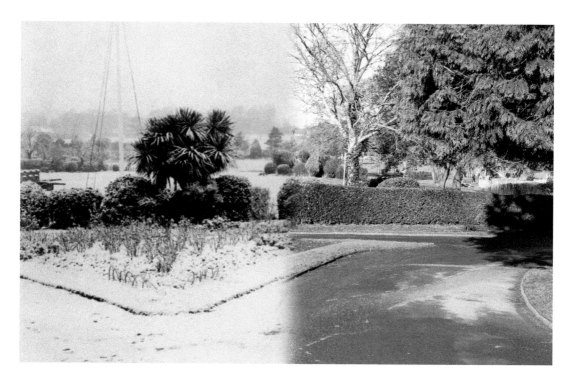

Victoria Park was officially opened in 1912, having been laid out on the site of an old marsh/ Victorian rubbish dump. One of its unusual features is the castellated bandstand that is surrounded by some old cannon on replica wooden mounts. The two shots here show these cannons on the left – in rather different weather conditions – one in 1935 and the other eighty-five years later. The shelter in the earlier photograph was removed many years ago.

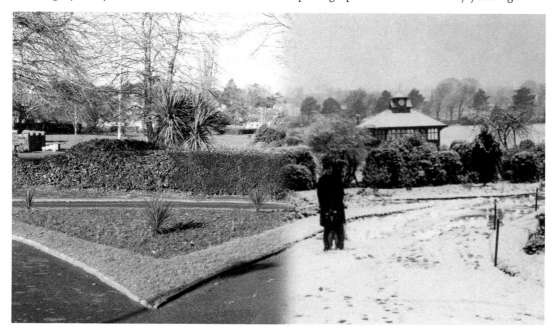

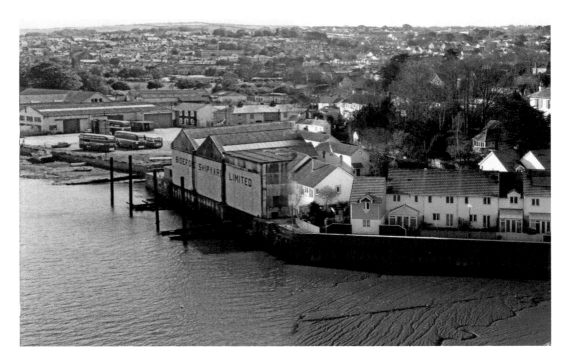

The Bideford Shipyard was founded in 1963 on a site that had first seen shipbuilding as early as around 1782. The site was at the northernmost end of the town and had the bus depot adjoining it. With cut-throat foreign competition, however, the yard closed as did the bus depot. Following rebuilding and strengthening of the riverside wall they were replaced by a new housing estate and Riverbank House, the headquarters of the district council.

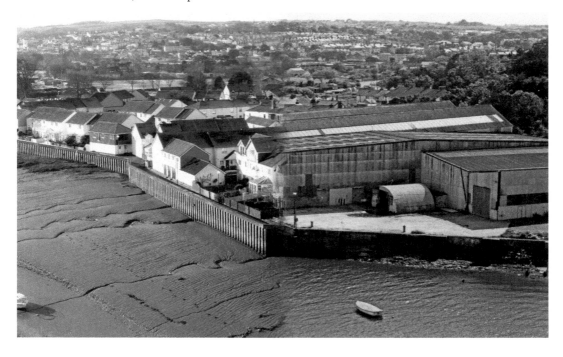

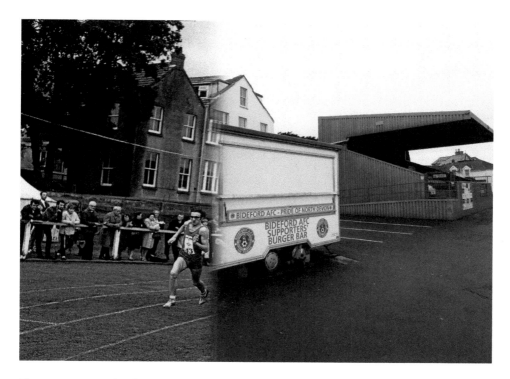

The Sports Ground today is the home of Bideford Football Club but in the past it also hosted athletics and here we see a race during the Regatta Sports of 1968. Note the old grandstand and the back of the Stella Maris convent school. In today's picture the grandstand has been replaced and new changing rooms have been built on the left, though the old convent is still there but was converted to residential accommodation some twenty years ago.

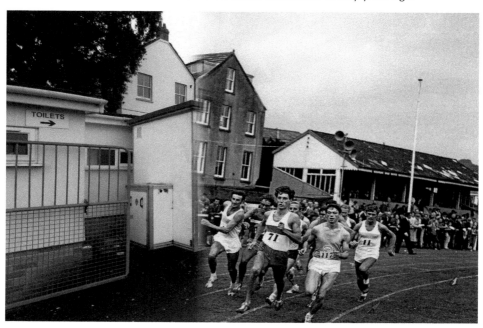

Northam Road in the mid-1930s showing the old doctor's surgery on the right fronting the large house called Stanhope. On the left is the building site that was to become Stanhope Terrace and a sub-post office. Notice how the opportunity was taken to widen the road at the time. The odd-looking column in the middle of the older photograph is one of the late nineteenth/early twentieth century sewer vents, of which six still survive around Bideford and are now listed monuments.

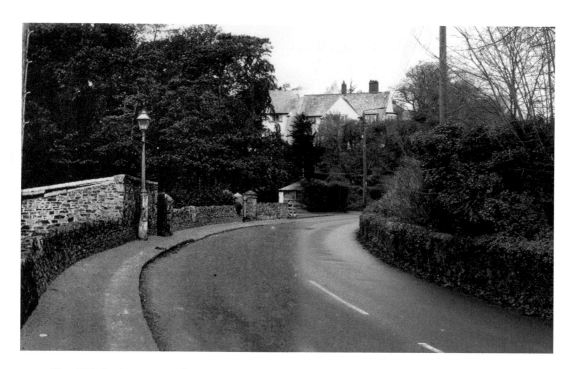

The Bideford, Westward Ho! & Appledore Railway left Bideford via the Kenwith Valley. The contractors built a level crossing where it met the Northam Road. The gates are seen in the early photograph with the lovely Arts and Crafts house above it. In today's shot the gates have gone but the house still remains. The original crossing guard's cottage is also still there but has long been derelict.

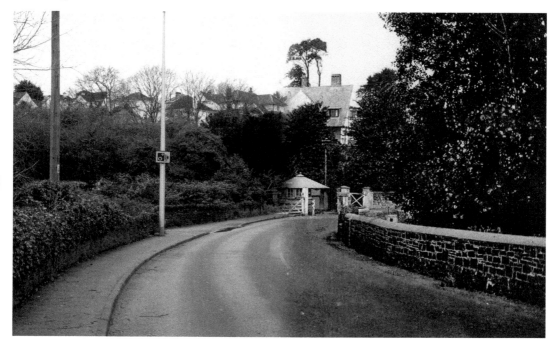

Queen Street is a quiet, atmospheric lane behind the Quay. Seen here from around 1895, the cobbled roadway stands out but note the gas lamp and the freight hoist. The three-storey building halfway along on the right was a nineteenth-century boy's school. Heard Brothers garage with its striking Belfast truss roof is thought to have become a garage around 1904.

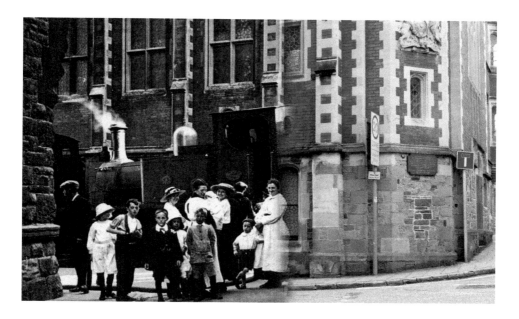

This early photograph records a unique occasion. In 1917 the War Office commandeered the three engines of the Bideford, Westward Ho! & Appledore Railway, and temporary track was laid across the Long Bridge to move them to the main line railway station at East-the-Water. Here one of the engines is backed up Bridge Street prior to crossing the bridge. The modern shot has a few extra signs but the town hall still looks as it did in 1917.

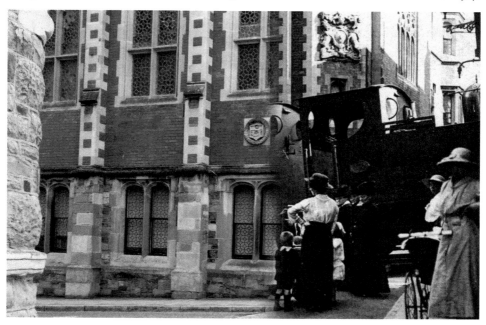

Allhalland Street is named after the chapel of All Hallows, which is thought to have once stood at the end of the bridge. Before the Quay was extended this small street would have been the main route into the town once the bridge was crossed. The shops may have changed but their frontages are virtually the same in both photographs.

This narrow thoroughfare lined with small cottages was New Street. The houses were removed in the 1960s slum clearance schemes, destroying a tight-knit community in the process. Today the right-hand side has been redeveloped as sheltered accommodation while the left is used for car parking to service shops in Mill Street. Note the granite slabs down the centre of the road in both shots.

North Road in the 1950s with a fascinating row of old cottages that have rather shaky roofs and tall chimneys, the latter indicating they were thatched in an earlier period. In the modern shot the chimneys have virtually all disappeared along with two of the cottages, which have been replaced by a pair of modern brick houses.

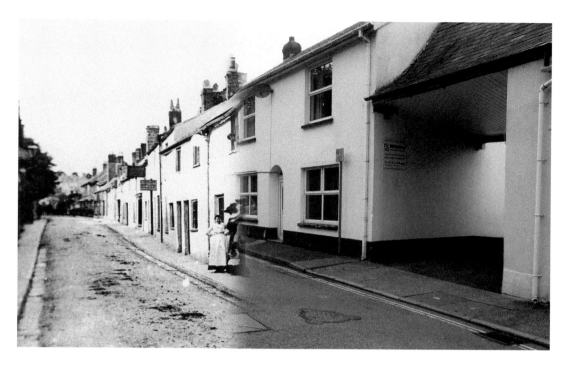

North Road was once the main route to Northam. Its original name was Potter's Lane as there were several large kilns behind the houses. These were established along the edge of the Kenwith stream (now culverted under The Pill), which was used by barges to bring the clay from Fremington. The last pottery here closed in 1893 and the opening of the Kingsley Road in 1926 created a new main road to Northam.

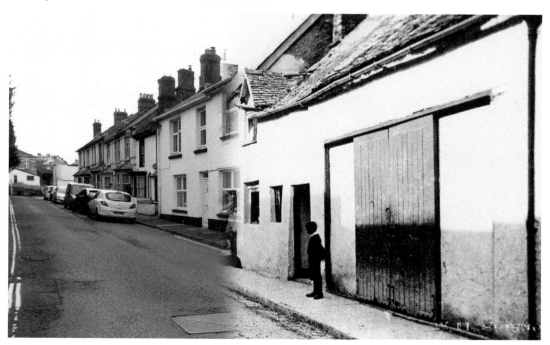

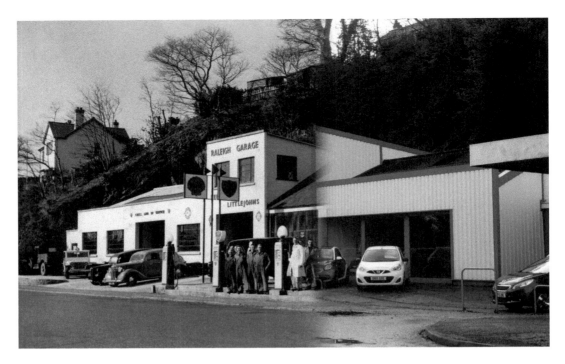

The Raleigh/Rydon garage goes back to the 1920s. Pictured in the late 1950s, the staff are seen here lined up by the five petrol pumps. Following a recent fire much of the premises had to be rebuilt. The petrol pumps have gone, although the garage remains, and the owners have diversified into selling used cars.

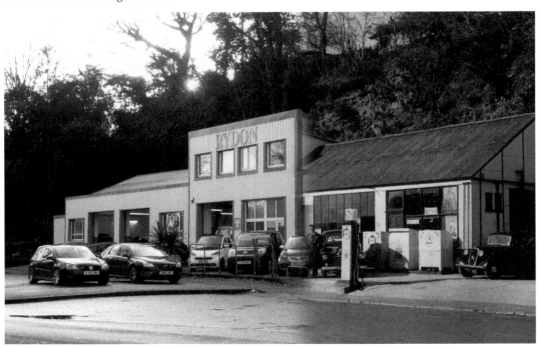

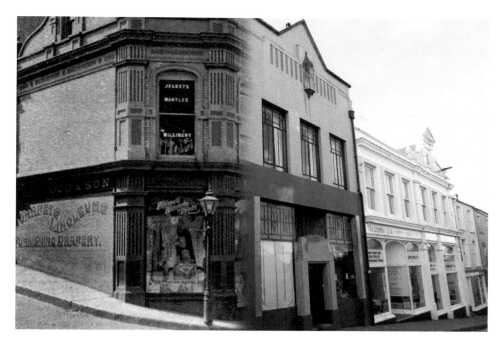

This magnificent Victorian draper's shop once stood on the corner at the top of Grenville Street. In 1934 a building society bought the site and replaced the building with a beautiful art deco-style office block. After some years they moved and a teachers' centre occupied the building, to be replaced by a printer's, and it is now a private residence, although it still contains many of its original art deco fittings.

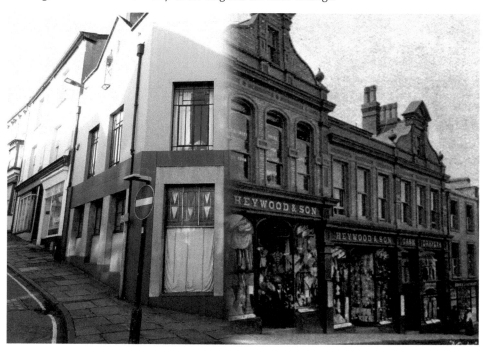

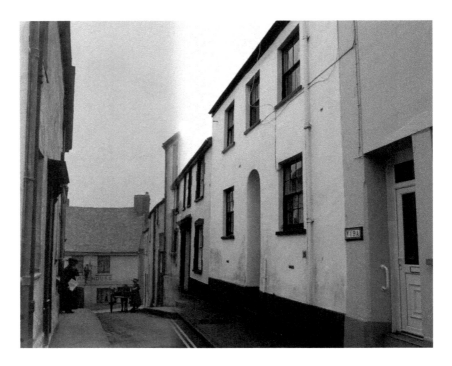

Silver Street is a narrow thoroughfare lined with terraces of varying date. The early photograph here dates from around 1890 and was taken looking towards Meddon Street. At some time the council undertook work to widen the road, and the steps disappeared with the protruding houses being set back and new steps going up to the front door. Additionally yellow lines have been put in place – for obvious reasons!

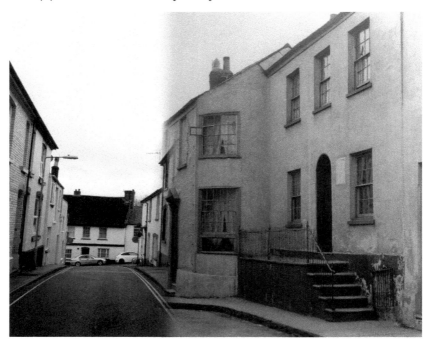

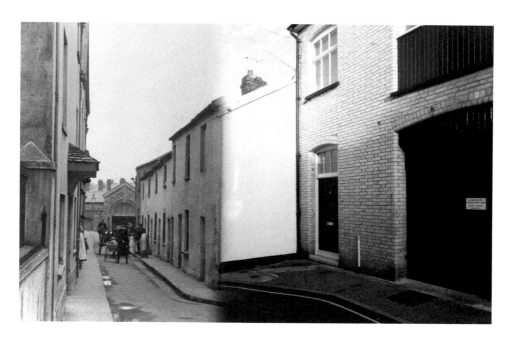

No one knows the derivation of the name Silver Street, a name found in many towns, but here is the Bideford example. Taken halfway along the street looking towards the Pannier Market, both shots highlight the narrowness of the road, which had two-way traffic up until a few years ago. Various windows and doors have disappeared along with the ornamental eagles decorating the building on the right, which must have been removed when the structure was altered to form a grocer's wholesale store.

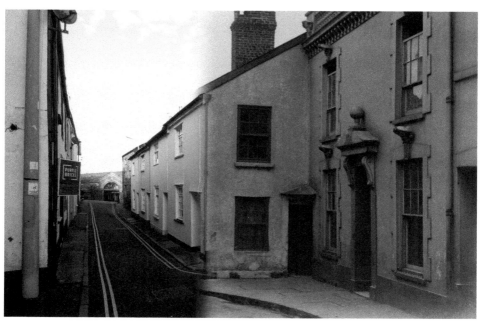

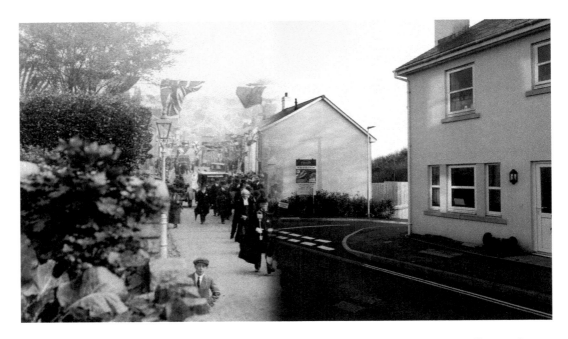

The 1925 photograph shows a ceremonial parade with Mayor Dr Edwin Toye, councillors and the fire brigade, all led by the town crier. They are processioning up Meddon Street, probably on the occasion of the annual Hospital Carnival. Today the Grenville Nursing Home on the right (Bideford's first custom-built hospital) has gone. replaced in the last few years by a new housing development. The council no longer processes up here – too much traffic.

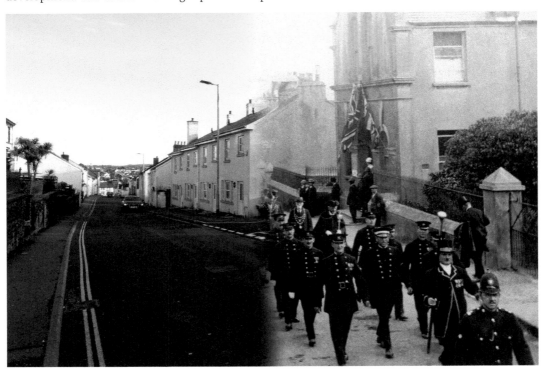

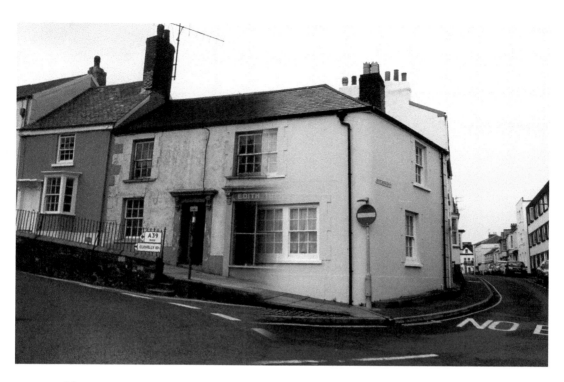

Meddon Street used to be a trunk road and had many shops including this one on the corner of Buttgarden Street. The two large windows have been replaced by domestic sash ones and the building looks a lot smarter. The railings in front are a rare survival from the Second World War as they were not taken as 'salvage' as they prevented pedestrians falling on to the road beneath.

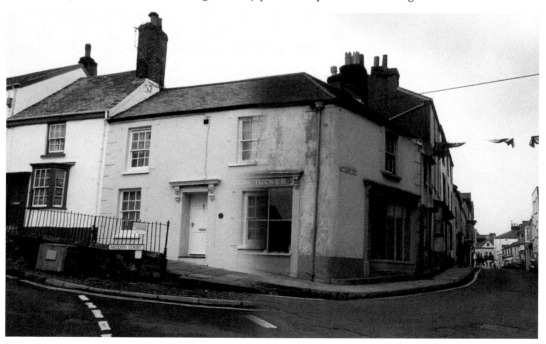

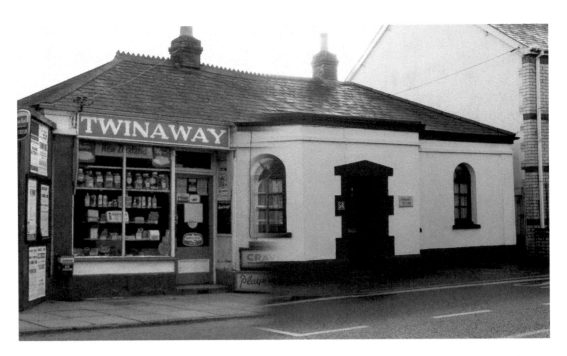

'Twinaway' began life as a toll house for the Bideford Turnpike Trust, where road users paid for the privilege of using an above standard thoroughfare. The turnpike was abolished in 1876 and the building sold off. Here from the 1950s we see one half of it being used as a small grocery shop. In the modern shot the building is now purely domestic. The rather delicate window tracery have been replaced by modern (and matching) windows.

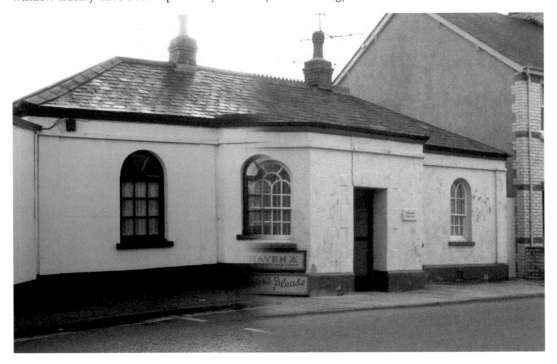

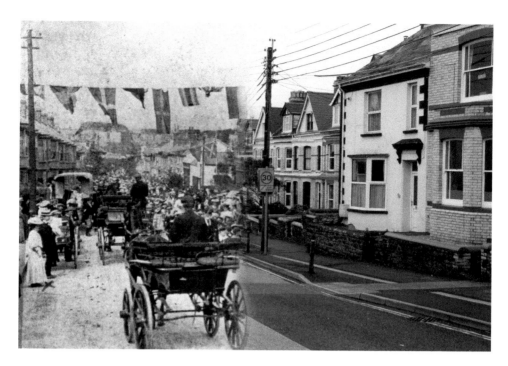

Clovelly Road used to be a major trunk road and even today it is a wide, handsome road. In May 1907 the Devon County Show came to Bideford and in a photograph from that date we see the mayor and councillors processing up to the show ground behind the town band. The view is still remarkably the same for most of its length.

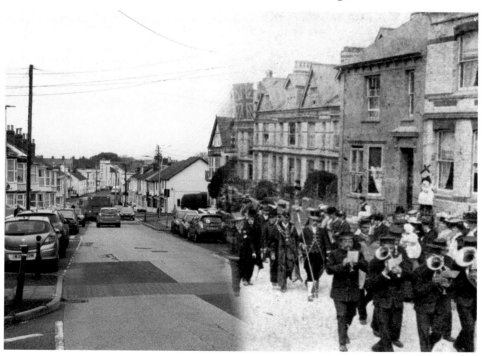

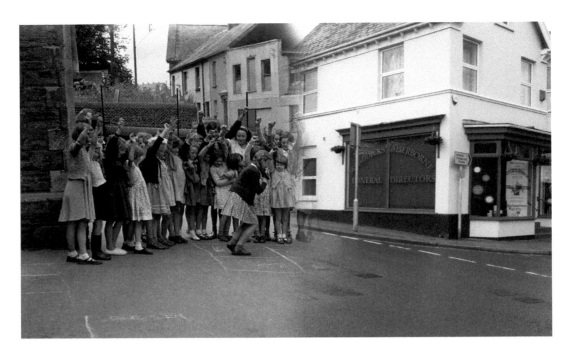

In 1845 the Church of England built a new primary school on the corner of High and Honestone Street on land given by the Bridge Trust. The playground was small but could host a game of hopscotch as shown here in a shot from 1954 with its crowd of excited onlookers. Later the buildings were taken over by the local angling club but today the old school has been changed into accommodation. The electrical goods shop in the background is now the premises of an undertaker.

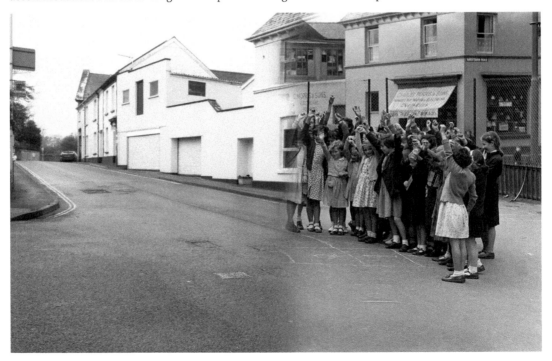

These two photographs highlight one of the great changes to our urban street scenes that has occurred almost by stealth. The site is the Old Town cemetery wall. Laid out in 1841 and last used in 1953, its boundary wall was used for large posters. Today, as with virtually every other bill posting site in Bideford, the posters have disappeared, along with the public toilets to the left. The wall was lowered a few years ago to give a better oversight of this secluded area.

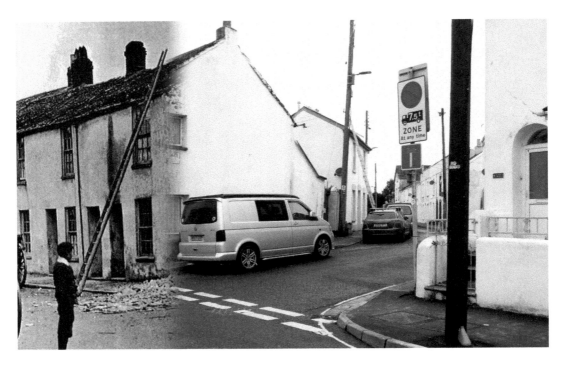

Milton Place is a small cul-de-sac leading off from Old Town, and even in the Edwardian period was difficult to access. In order to improve it the corner cottage was demolished around 110 years ago. Today the access is wider but parked vehicles have now limited it once more, albeit on a temporary basis.

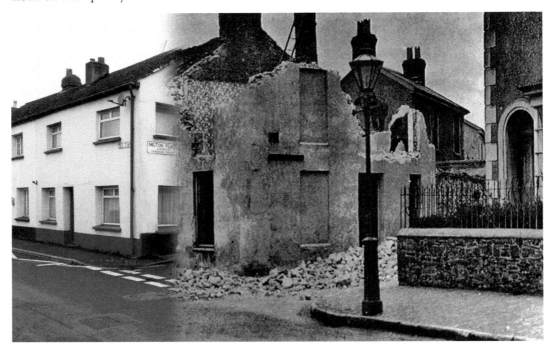

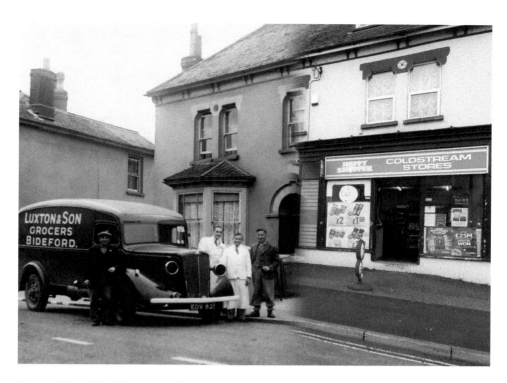

Corner shops like this one at the junction of Meddon Street and Clovelly Road were once common but the unstoppable spread of supermarkets and now the internet has seen many disappear. This one, however, still survives. The first shot dates from the 1930s and shows the shop owner's new-looking delivery van while the second has a more modern frontage, although the rest of the building looks relatively the same.

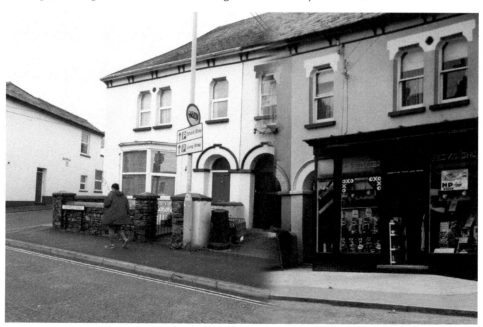

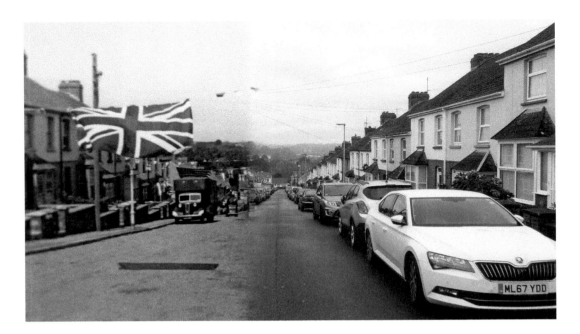

At the end of the Second World War virtually every street in Britain seems to have held a street party and here we see Royston Road with flags and bunting strung across the road to mark the event. Seventy-five years later the roadway is now full of cars but the houses are still recognisable, though satellite dishes have sprouted on a few of them.

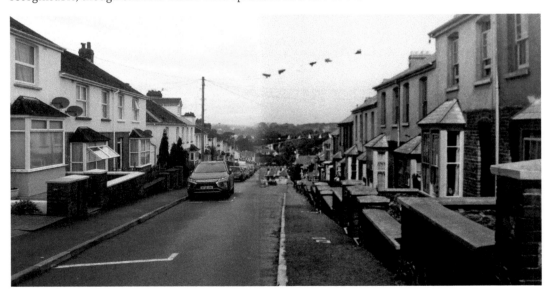

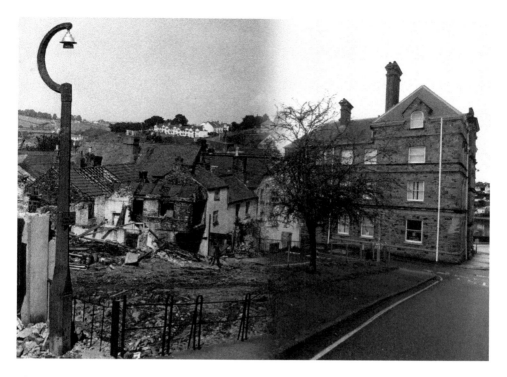

The 1969 photograph shows the clearance of the old houses and shops that used to stand in Bridge Street. Demolished under slum clearance legislation, the area is now a large town centre car park. The handsome building to the rear was built in 1882 for the Bridge Trust and from 1974 until a year or two ago housed Torridge District Council offices. The buildings to the left have been carefully refurbished and, after being the local MP's constituency office, now house a hairdressing salon.

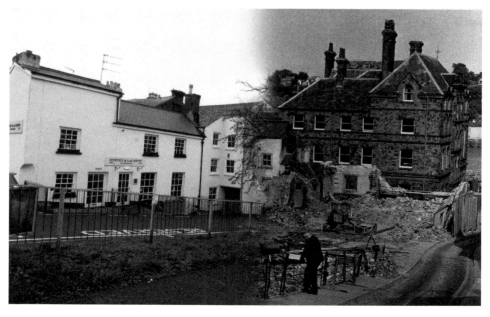

Bridge Street now consists of a few houses on one side and extensive car parks on the other. One of these latter once housed this massive Methodist church. Known as the 'Nonconformist Cathedral of North Devon', it was built in 1892 and is seen here being demolished some eighty years later. Its removal only followed a court case where one section of the congregation sought to save the building against the wishes of another section who sought demolition. The latter won but their victory led to a split in the congregation that was never really healed.

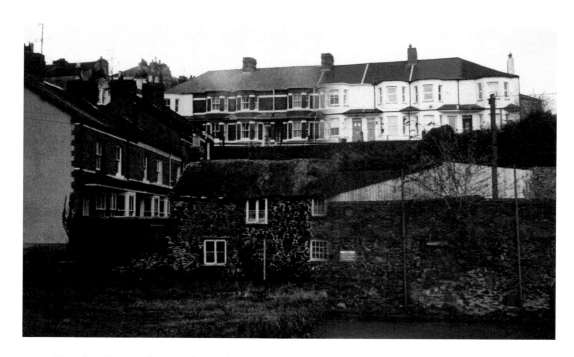

Kingsley Terrace looms above this wonderful example of a Devon longhouse in this 1960s photograph. The terrace itself is said to stand on an English Civil War earthwork, which overlooked and controlled the River Torridge. The modern shot shows the longhouse has gone, removed in the early 1970s to form a car park. The terrace has been painted white for the most part reinforcing Bideford's title of 'the Little White Town'.

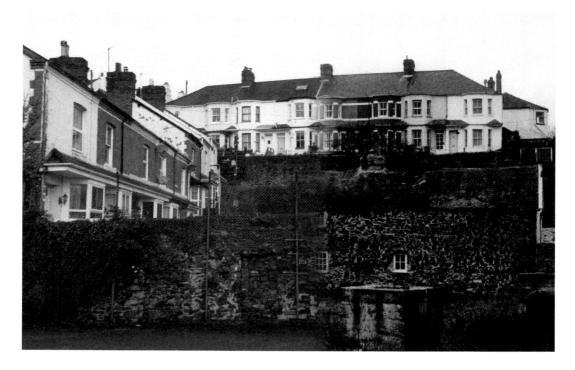

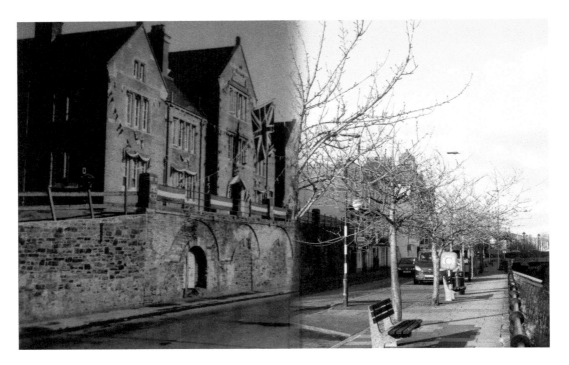

The Bideford police station was opened in 1898 following the amalgamation of the old borough force with the Devon County Constabulary. It was built on top of a range of coal cellars whose arches are still evident today. The two photographs show firstly the building decorated for the coronation of George VI in 1936 and secondly the building today, which, though still in use, is not open to the public.

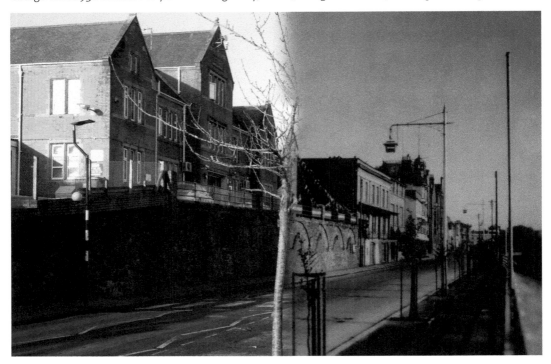

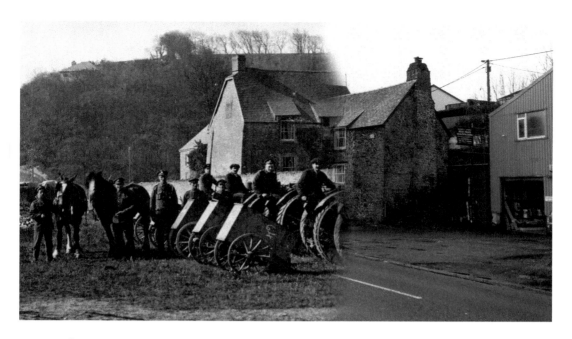

Ford House is often said to be the oldest house in Bideford but here it forms the backdrop to a line-up of the first tractors in North Devon. Introduced during the First World War to replace conscripted farm workers, they helped maintain the nation's food supply, and it seems a few soldiers were released from the forces to drive these new-fangled vehicles. In the modern shot the photographer has managed to capture a modern counterpart – a nice combination.

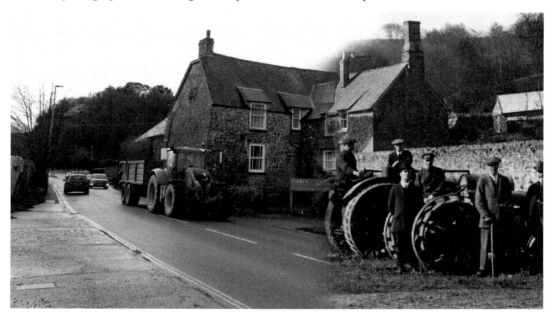

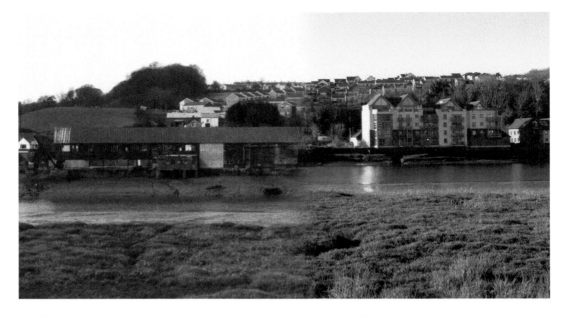

The long wooden building in this picture is Blackmore's shipbuilding yard. Started in 1933 and closed in 1963, it specialised in wooden vessels, building a range of minesweepers and motor torpedo boats during the Second World War. Behind the now empty buildings the Devonshire Park estate can be seen. Today the shipyard is gone to be replaced with a high-rise development of flats and a second-hand car lot.

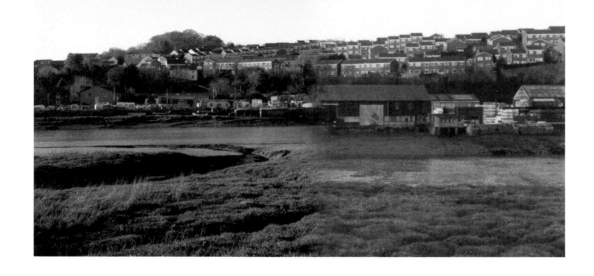

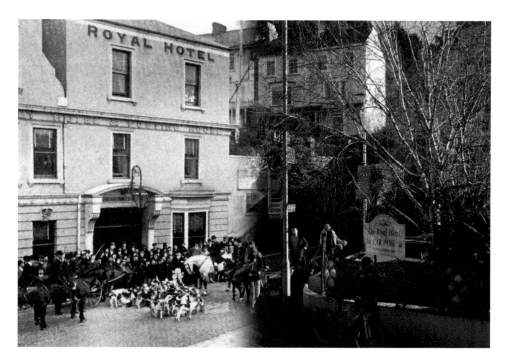

The Royal Hotel began life as a large merchant's house in the seventeenth century and became a hotel in 1889. Now owned by the Brend Hotel group, it is seen here around 1905 when the local hunt met outside it, with crowds lining the railway bridge between the Hotel and Springfield Terrace. The hotel still acts as a meeting place today for local groups and organisations.

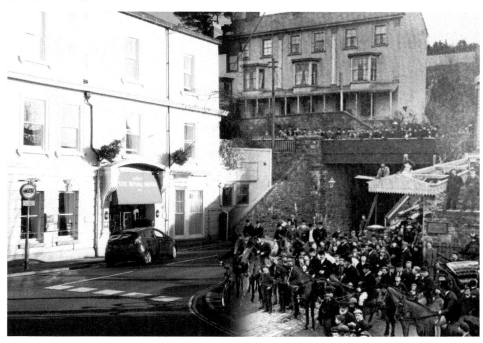

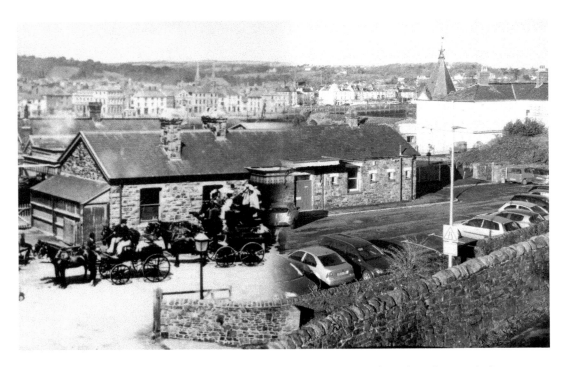

Bideford's railway station was built in 1872 and is seen here in the Edwardian period as a selection of coaches take on passengers who have just alighted from a newly arrived train. Closed under the Beeching cuts in 1965, the building later housed a bank and is currently empty, although its yard provides car parking for the Royal Hotel.

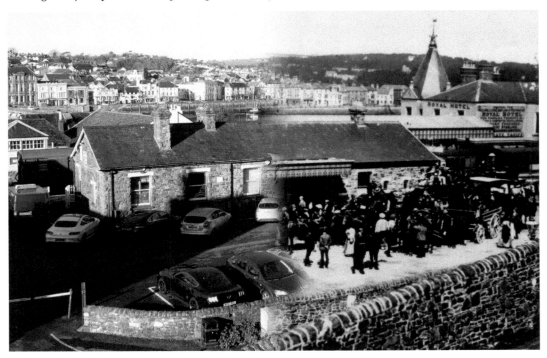

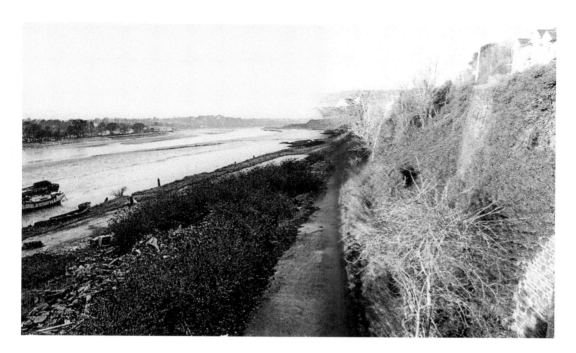

The railway goods yard used to stand on made-up land at East-the-Water until it was closed in the mid-1960s. The area remained empty for many years until it was purchased by Torridge District Council, who erected a range of sheltered accommodation on the site in 1981. It was named Ethelwynne Brown Close after a deceased councillor. The railway line in the photograph was taken up and replaced with the Tarka Trail – a very successful bicycle/pedestrian route.

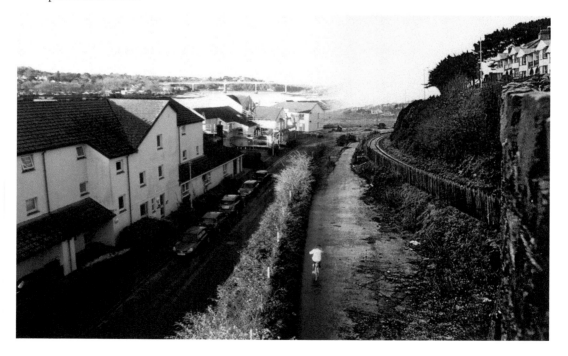

Looking up Torrington Lane in the past one would have seen this well-known corner shop at the junction of the Lane and Torridge Mount. The steady spread of supermarkets in the post-war years saw the shop disappear and the building converted into accommodation, though the windows above the old premises still look much the same.

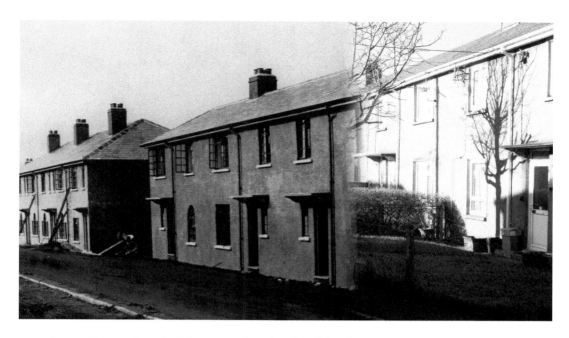

Sentry Corner, East-the-Water, was first developed by the town council in 1929. Designed to provide good but affordable housing, the estate is seen here during construction. The modern photograph shows new innovations such as cars and satellite dishes, and new double-glazed windows have replaced the metal-framed ones initially installed.

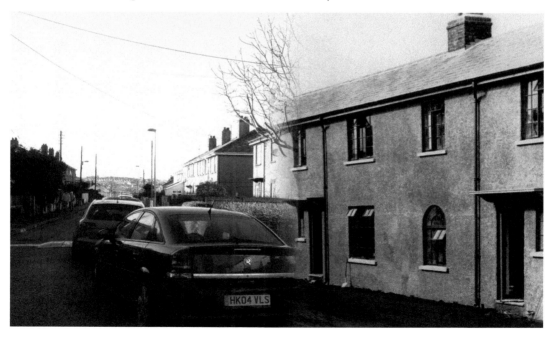

Acknowledgements

Firstly, we must thank the photographers of the past who captured the views we have used. We must also thank the members of the public who agreed to appear in today's shots, and a special thanks to Ben Braddick, the 'Reds' rowing club and the Bideford Arts Centre who allowed Graham access to their buildings to recreate several shots.

About the Authors

Photographer Graham Hobbs captured his first image in 1968 on his father's Brownie box camera, which he still has to this day. From the early 1980s he has been regularly photographing events for local newspapers. His images have also been used on calendars, greeting cards and a variety of websites and he has received worldwide recognition for having a good commercial eye. He has been appointed official photographer for a royal visit to the West Country, has also featured in radio programmes and, in 2018, appeared live on ITV talking about how he filmed a robin he christened Charlie. An online posting about this bird went viral. Graham says of his art: 'I am only as good as the subjects I am capturing so therefore I appreciate the world of photography.'

Peter Christie is a retired teacher whose articles on Bideford life appear weekly in the *North Devon Journal*, where he has also published the 'Yesteryear' photographs for the last fifteen years. He was the Reviews Editor of *The Local Historian* magazine (published by the British Association for Local History) for twelve years and a long-time Open University lecturer. He is the longest-serving councillor on both Torridge District and Bideford town councils, having been chairman of the former and is currently serving his third term as Mayor of Bideford. He has been chairman of the Bideford Bridge Trust on three occasions, is a trustee of the North Devon Museum Trust and chairman of the North Devon Athenaeum. This is his thirty-seventh book.